Cole Weston

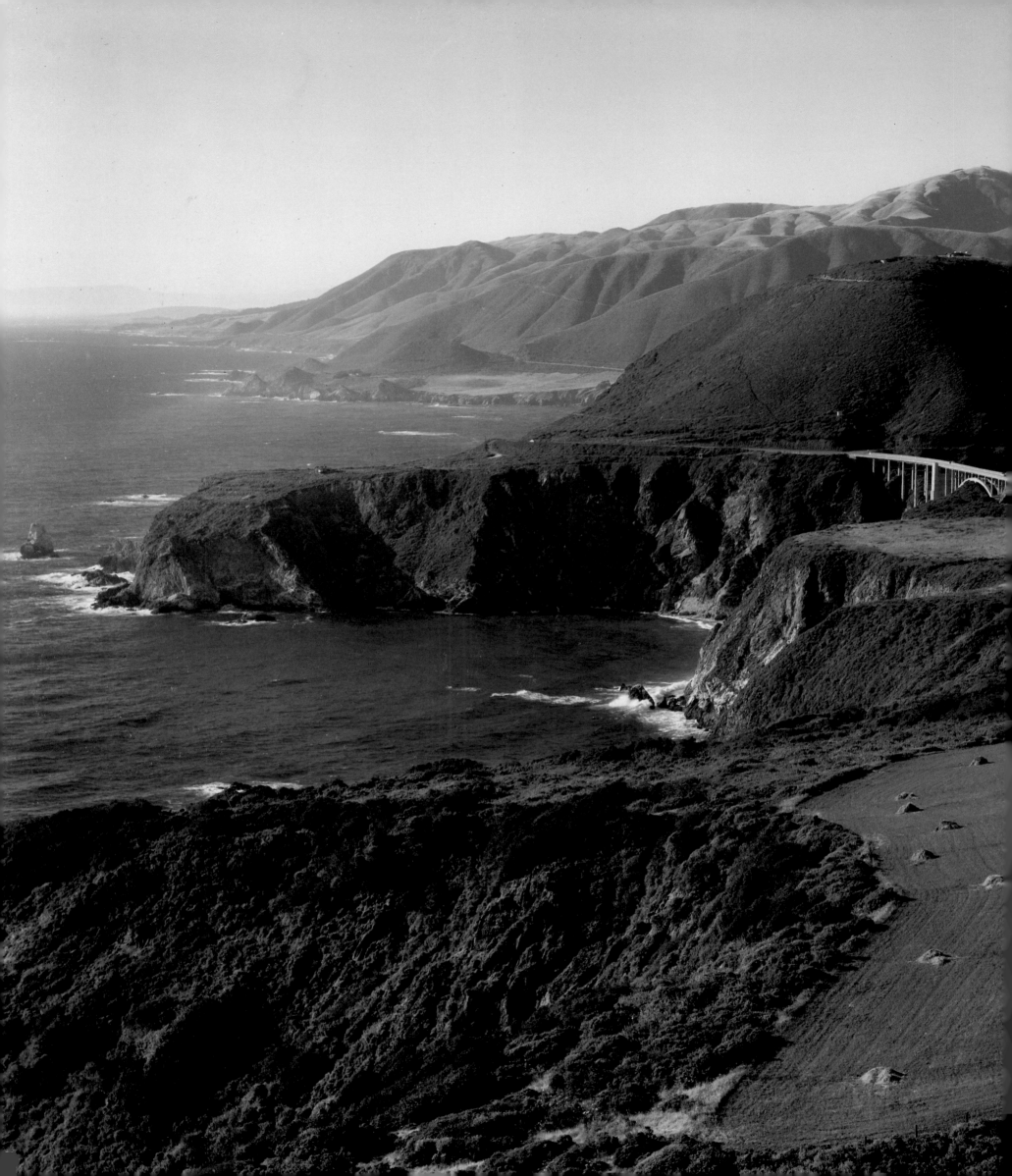

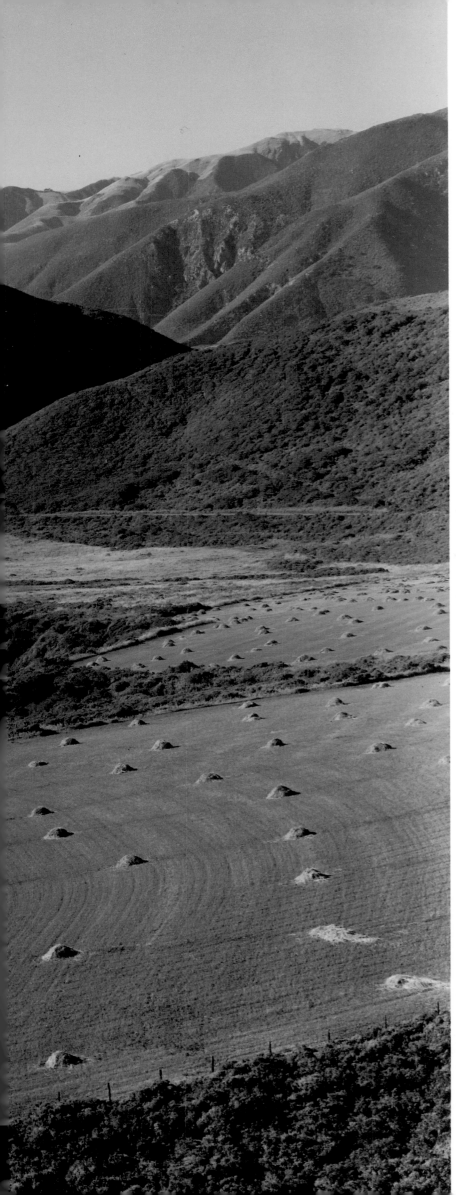

Cole Weston
At Home and Abroad

Introduction by
PAUL WOLF

APERTURE

BIXBY BRIDGE AND COAST
NORTH, CALIFORNIA, 1958

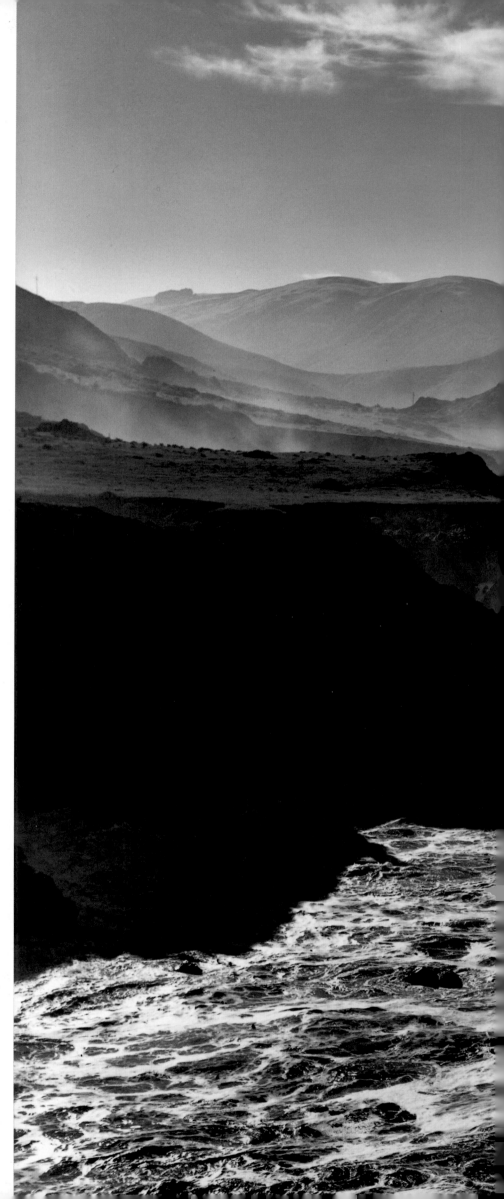

DEDICATED TO MY WIFE,
MY CHILDREN,
AND MY FRIENDS

THIS PUBLICATION IS MADE POSSIBLE
BY THE GENEROUS SUPPORT OF
ROBERT YELLOWLEES
AND FRIENDS OF COLE WESTON:
EUGENE H. AND ELLA BOULIGNY,
RICHARD CHEPEY AND ANNETTE SMITH,
MARIE COLSON,
MEMORY OF SUE SELLORS FINLEY,
NANCY AND CHARLES KAFFIE

SURF AND HEADLANDS, CALIFORNIA, 1958

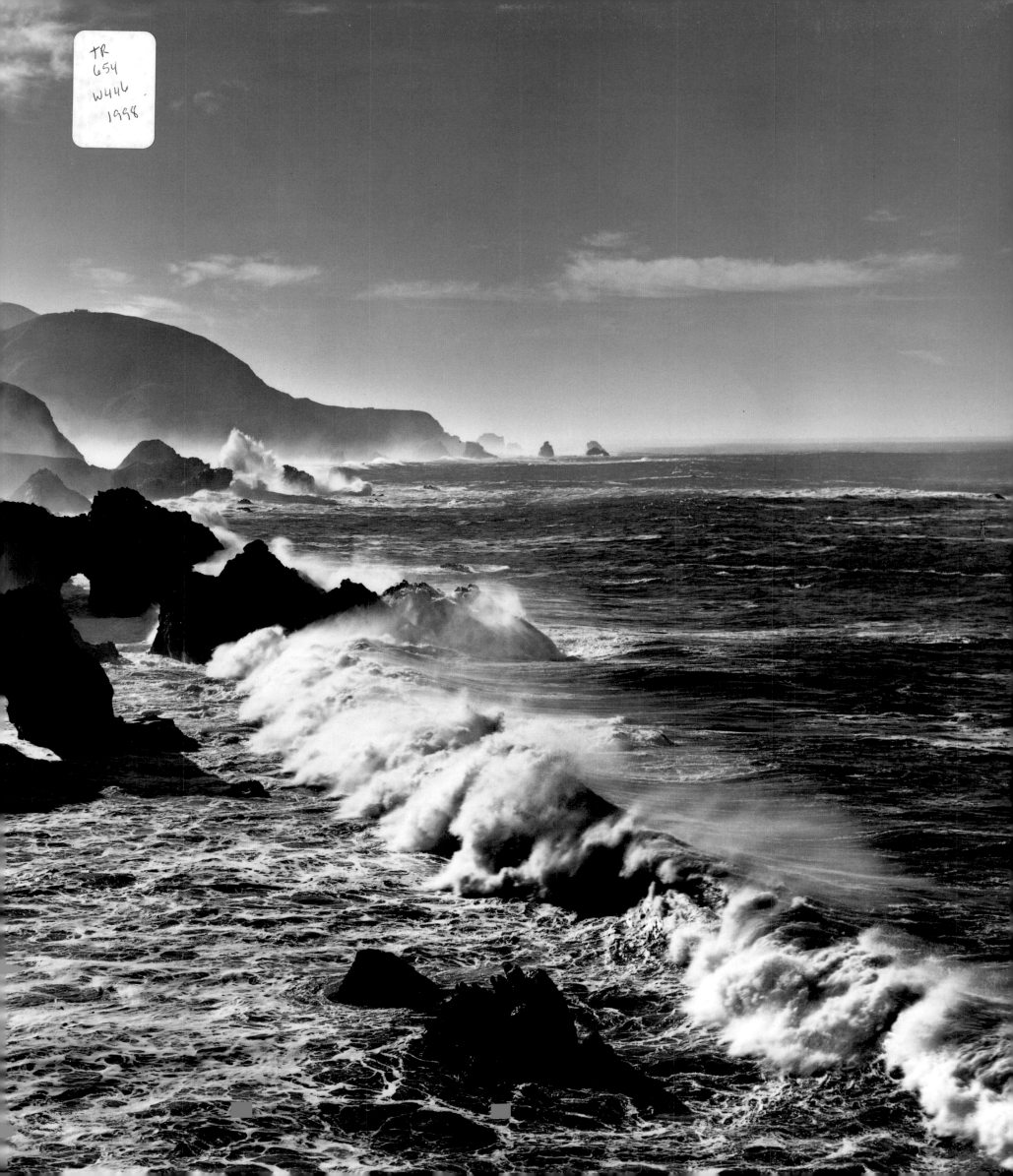

Cole Weston
A Long Day's Journey Into Light

BY PAUL WOLF

The journey into this photographer's life starts at the open-air Forest Theater in Carmel-by-the-Sea, California, where a bronze head bolted to a concrete pedestal watches the stage with a piercing, constant gaze.

Situated between a grove of trees and rows of wooden seats, the bust is spare and abstract, but the angular features of Cole Weston come through. "These eyes aren't quite right, but it's pretty good," the real Cole Weston says, critiquing his likeness the way he would critique anything he cares about: a play, a photograph, an adventure at sea—or a woman. His observations are astute, his manner tender and unabashedly cheerful.

In this wooded setting, the trees have deep roots, as does the community. We have happened upon what was once the center of Carmel culture, which, sadly, many modern Carmelites couldn't find without explicit directions. If the photographer, whose first love was theater, had his way, the community would restore the outdoor venue to a central place in its heart.

Cole's best hope would be to find a young successor to champion what he calls "theater with balls," someone to fight for *The Grapes of Wrath* over *Oklahoma!* The statue attests to the respect for his view that exists in the town. The sculptor of the piece, Lou Roberts, says the work doesn't capture the man at any one point in his fifty-year association with California's first outdoor community theater. It's just him, in an archetypal pose, watching the proceedings with a keen eye—a photographer's eye, to be exact. Cole has always done theater with a photographer's eye, and photography with a director's flair. In both arenas, Weston the man personifies charisma, passion, and love of living.

Should our collective camera zoom in on the bust's inscription, we would be able to read the words: "Cole Weston . . . the life force of the Forest Theater for half a century."

As the statue suggests, Cole Weston's contribution goes beyond being keeper of the Edward Weston flame, custodian to the legacy of the modernist imagemaker and visionary giant. Once a footnote in the context of the master, Cole Weston has emerged as a photographer of strength, feeling, and recurrent brilliance. In addition, he has contributed his lasting concern for the communal flame. As the townspeople have recognized, he is a champion of the arts and a tireless promoter of regional talent.

At this shady amphitheater, Cole is sometimes beset by melancholy. In his eyes, the Carmel of the 1930s and 1940s—the Carmel of boyhood and bohemia—has been mostly lost to the rush of development and commercialization. Now seventy-nine, Cole has worked much of his lifetime to preserve the legacies of family and community. A decade after Cole printed his last Edward Weston negatives, he is out from his father's shadow. And at Forest Theater, his own legacy is literally casting a shadow of its own.

BOHEMIA-BY-THE-SEA

For our next step on this journey, we need not travel far in distance—only several hundred yards—but back through nearly seventy years in time. We have arrived at semi-wilderness, and we find yet more trees, occasional cottages, and a newly paved main street, where we enjoy blessed pauses between automobiles and the occasional sight of a lone policeman on horseback. Our eyes find three wooden buildings: a tiny house, separate sleeping quarters, and a rustic photographic studio. This is Carmel, 1929—the site of the first Weston home and work space in Carmel-by-the-Sea, where Cole spent his preteen years.

"Between the wilderness, you knew every house and everyone who lived there," reflects David Hagemeyer, Cole's lifelong friend, and nephew of photographer Johan Hagemeyer, who rented the property to Edward Weston.

Cole wouldn't take much notice of the community stage for many years, and art photography was something his father and older brother Brett did—albeit with devotion and joy—when not tending to bread-earning portrait work. Edward Weston spent most of Cole's boyhood on shoots or printing over trays of chemicals. Indeed, for his whole life, Edward lived what Ansel Adams later described as "a monk-like existence."

Despite all this, Edward and his four sons, Chandler, Brett, Neil, and Cole, constituted a genuine slice of bohemia. They enjoyed the offbeat, unconventional, and creative ways of Carmel living at this time—sunbathing on the roof, wild costume parties, philosophical chats with photographers and writers like Robinson Jeffers and the journalist Lincoln Steffens.

Over the decades, the city of Carmel has institutionalized its culture and its past. Today, a city staff of only eighty-two runs full-fledged departments for forestry, library, and culture. Cole served as the Cultural Department's first manager in the late 1960s. Today, for its 4,200 residents, the city runs two library branches and a much-used local history archive/study center, which houses 119 Edward Weston prints. Arlene Hess, librarian of the local history room, says Edward Weston is among the most studied local figures in a town renowned for legendary artists.

Despite these enlightened policies and programs, the character of Carmel's culture has been transformed amid scores of art galleries, sky-high property values, and year-round tourism. Carmel's defenders argue that the town has been spruced-up and made to sparkle.

Today, a few blocks from where Edward feared his darkroom would leak light if a truck drove too fast on Ocean Avenue, the Weston Gallery sells EW/CW prints (Edward's images printed by Cole) for up to $3,500. During most of his lifetime, Edward could scarcely sell his fine-art images at all and churned out portraits on commission to pay his rent.

The 1920s and 1930s witnessed the peak of a new way of seeing and photographing—photographic modernism.

SEDONA, ARIZONA, 1978, PHOTOGRAPH BY JOHN BOLAND

Edward Weston was at the forefront of this change, in the company of other Carmel and West Coast notables such as Johan Hagemeyer, Margarethe Mather, Imogen Cunningham, and Ansel Adams.

Growing up in Carmel, Cole couldn't help but develop a great respect for the artist and his or her role in society. Cole had many models in and out of the home, and they all communicated the message that the soul's purpose is to create.

UNCONVENTIONAL LIVES

Beyond the idealized portraits of Edward Weston and early Carmel lie grittier images of the Great Depression: a young boy's homesickness for Southern California and other reminders that a creative milieu can't change the hard stuff of life. There is the image of a boy, Cole, sitting at a table

eating Thanksgiving turkey alone; his father off exploring some photographic impulse; brothers scattered and absorbed in their own interests; mother, Flora, sacked-out in bed, retiring early as she often did after work.

There is another image—that of Edward and his oldest son, Chandler, leaving Flora and the other boys behind at the dock in Southern California as he sailed off for a year-and-a-half long trip to Mexico with Tina Modotti, the actress and photographer. It was a sad, confusing experience for Cole, who stood with his mother, waving goodbye to his brother, his father and his father's mistress. Edward captured this disturbing scene with a snapshot from the boat.

There were two sides, the light and the dark, of growing up a Weston. Cole says, "I never remember Dad really being a father figure because we never sat down, all of us, as a family. I have no memories of my mother and father being a union." His parents would be separated for good by the time Edward moved with his sons to Carmel. As a child, Cole shuttled north and south between his mother and father. To his credit, he has not tried to compensate for feelings of abandonment by embarking upon some all-out quest for security and stability. His life has been remarkably free-form, a striking creation in its own right.

Edward's daybooks, letters, and Cole's own memories reveal that Edward was actually quite devoted to his children; loving and attentive to their problems. But a perfect role model he wasn't. As Cole has written, "I recall Dad asking me to go out and watch for the red streetcar; a young lady visitor had to catch her ride back to Los Angeles. I went out, but sneaked back and found my father in a close embrace with the woman in his darkroom. So you see, my beginning in photography was with some rather mixed emotions."

Cole remains mystified about how he was conceived. His mother, a school teacher of forceful personality, was estranged from his father well before his birth, and Edward was already in the arms of a mistress. Cole guesses that Edward and Flora "got together once more for old time's sake."

Edward wrote harshly of Flora's boisterous, bossy temperament, an emotional counterpoint to his own low-key manner. Interestingly, the couple did not divorce until 1936, and Edward and the boys enjoyed Flora's acceptance,

support, and love despite an unconventional setup that couldn't have been to her advantage. Her financial support of the boys, and even of Edward, continued after the divorce. When Cole was a student at the Cornish School of Drama in Seattle, Washington, he relied on his mother's monthly $20 check.

One of Cole's earliest memories has him pushing a toy boat around in his father's darkroom sink. When Cole was eight, Brett—who would lead his younger brother on many photographic excursions—took him to Mt. Wilson, where he made his first photographs. A few years later, in 1930, Brett traded Cole a 4-by-5 Auto Graflex camera for a pair of pants.

As a teenager, Cole chummed around with two Carmel boys, David Hagemeyer and John Short. With the extroverted Cole as the ringleader, "the filthy three" stole things compulsively—bottles of wine, vegetables—drank beer on weekends and danced to up-tempo music with their girlfriends. By today's standards, their rowdy behavior was restrained, but it expressed a sense of drama and adventure that Cole would never lose.

David and Cole often hitchhiked to the nearby town of Monterey to catch a movie. Cole would try every trick in the book to stop a motorist, acting out one-man skits, marching into the wind with feigned struggle. Hagemeyer says: "He hasn't changed one bit in the seventy years I've known him. He was always a naturally extroverted actor. He attracted a lot of attention. My nature has always been shy and timid, but he is neither one of these things. He has pushed me along, and that has been valuable to me."

Sudden enthusiasms have always been a part of Cole's behavior. When they are mixed with a spirit of generosity, Cole is at his very best. Hagemeyer remembers that when he and Cole were in their late twenties, Cole insisted on helping him build his dream house, a ranch-style home made entirely of adobe. Cole spent the better part of two weeks helping Hagemeyer and his wife, Jeanne, make and then transport hundreds of fifty-five-pound bricks for the job.

When Cole was a boy and young man, "living off raisins and peanuts" was the reality of his family's condition, Hagemeyer recalls. The boys were well aware of Edward's fame within the photographic world, but in this village of artists,

poets, authors, dramatists, and eccentrics, no luster of celebrity enveloped the private man and his brood. The Westons were well-known to those who had an interest in photography, but that was it. When Edward died in 1958, he had only $300 in the bank. "They had no sophisticated ideas about themselves," Hagemeyer adds. "Everyone was proud of Edward, but they never gave me the feeling of being star-struck."

It was not just Edward who achieved a certain degree of fame. Brett's stature rose quickly by the time the family moved to Carmel in 1929. Having assisted in Edward's portrait business in Glendale, Brett had exhibited his work in Los Angeles and, in his first year in Carmel, at age seventeen, he received worldwide recognition by showing work in the *Film und Foto* exhibition in Stuttgart, Germany. Edward considered Brett to be an influence on his own work and further along than he himself had been at the same age.

Cole was bit by the stage bug after he played a part during his senior year in high school. When he informed his father of his intention to be an actor, Edward, a friend of Nellie Cornish of the Cornish School of Drama in Seattle, helped Cole arrange a work-study program. The curriculum was a wild assortment of dance, stagecraft, acting, radio, and fencing. "I have never been so busy in all my life," Cole wrote his father from Seattle. "I am at school about fourteen hours a day working my fool head off . . . but I love it."

A fellow Cornish student, Jack Tyo, remembers the lanky, prominent-chinned, easy-smiling extrovert as being "very flamboyant and dashing." He was also "loud in his opinions," Tyo recalls. Cole's saving graces—that those opinions were thoughtful, and that he had a great deal of personal warmth—earned him many friends. It was at Cornish that Cole met a dancer named Dorothy Hermann, whom he married in 1940.

Back in Carmel in 1937, Edward was blessed with good fortune when he became the first photographer ever to receive the Guggenheim Foundation Fellowship, which freed him, for the time being, of repugnant commercial portrait work.

Cole's fortunes also seemed to be on the rise. In August of that year, the twenty-one-year-old actor had the intoxicating experience of reading a column in the Seattle *Daily Times* that praised one of his performances. The dark clouds of World War II, however, soon blew into this picture.

The newly graduated drama major played his part for the war effort by working for Lockheed in Southern California, quickly learning metalsmithing. An improved financial condition was little compensation for someone of Cole's temperament. "God, the life of an aircraft worker is boring when I think of the swell times I had at Cornish when I wasn't a wage slave," he wrote.

Between 1941 and 1945, Cole dabbled in amateur theater wherever he and Dorothy found themselves. Also, photography began to tug at him with a surprising urgency. In 1943, Cole started a portrait business to supplement his income.

During the last two years of the war, he was a landlocked sailor and public-relations photographer at a naval base in Norman, Oklahoma. A little name-dropping was just the trick to gain full access to an overbooked Navy darkroom. Cole had a refreshingly honest assessment of his photographic abilities at the time, telling his father that he was dissatisfied with his own work and thought he had potential only because he grew up a Weston. Nor did he revel in his talent when a customer applauded a portrait he did in "good, straight, natural light," as he confessed in a letter at that time.

But, as he wrote in 1946, Cole soon saw signs of progress in his efforts outside the studio: "It's amazing to me, how the more you work, the more you see . . . the barns, trees, dilapidated houses, gullies, ruts, and riverbeds which I once took more or less for granted. I won't say that I passed them up without noticing them, because that would be impossible considering my upbringing, but now these have all become exciting subjects for me."

In his years away from home, Edward continued to be Cole's mentor in photography and in all things. "Your calm, collected, and simple approach to the complexities of life will always be something for me to remember," Cole wrote to his father in 1945.

Cole kept up with his own portrait business, still a financial imperative, and worked as a stringer for *Life* magazine at the behest of an old friend, Peter Stackpole. He viewed the magazine gig with scorn, arguing that *Life* photogra-

phers made up for a shortcoming in craft by shooting many rolls of film in hopes of getting lucky. Cole has always kept for himself his father's discipline—one or two shots of a scene and that's it. Edward's perfectionism, rigorous "straight" printing requirements, and insistence on "pre-visualizing" shots were internalized by Cole during their years of working together.

Two monumental events changed the Weston's lives in 1946: Edward's divorce from Charis Wilson, whom he had married in 1939, and his diagnosis with Parkinson's disease. Cole and Dorothy pulled up stakes in their new Southern California home and came to live with Edward in Carmel. Cole suspended many of his personal pursuits to become his father's assistant for the next twelve years. As Edward's motor skills deteriorated, it fell to Cole to hold his father's camera and adjust the knobs, to print negatives and arrange shows.

In 1948, the flamboyant twenty-nine-year-old Cole took a surprising turn toward politics. Angered by the hysterical anti-Russia sentiment that pervaded the nation, he ran for Congress on the Independent Progressive party ticket. His candidacy was "dead serious," although Cole will admit to a certain attention-getting impulse. He traveled the coast with a sign that read "Win With Weston," which was pelted by tomatoes on at least one occasion.

Although the Red-baiting he suffered drove away most of his portrait business, on the bright side it compelled him to find a more enjoyable way of making a living. In 1948, he bought a piece of canyon land at Garrapata Creek, ten miles south of Carmel, where he has lived continuously ever since. He turned to trout farming, and soon had three farms in operation.

For thirty years after Edward's death in 1958, Cole continued to arrange shows of Edward's work and to print and sell his "greatest hits." Edward's will left instructions that all such images be stamped "Negative by Edward Weston, Print by Cole Weston," and be sold for no less than $30 apiece. The photography world's appreciation of the prints Cole produced does not diminish the hard fact of the years of toil he endured in keeping his father's name alive. He describes the printing process he used before and after his father's death: "Just as he taught me, I worked with a light bulb hanging from the ceiling over a printing frame, which had the unexposed paper and the negative in it. He used no electronic timer, and neither did I. Instead there was a rusty old alarm clock which ticked off the seconds, and so he just counted. He developed in the solution using a three-minute egg timer." Cole brought in improvements one at a time—an electronic timer, fast-developing projection paper instead of contact paper.

Cole often ponders what his life would have been had he gone into directing full-time in the late 1940s. Working for his father hampered his own creativity and limited his horizons, despite the incomparable training. "I'm sure in my subconscious it might have bothered me just to be Dad's assistant all those years," he says now. "But I had other places where I was admired."

Today, Cole smiles at being labeled a "pioneer" in color. Truth be told, he was all too happy to find a way to make a mark apart from the Edward and Brett mold. But Cole modestly attributes his use of color to a fluke of timing rather than to a personal innovation. In 1947, Eastman Kodak began sending boxes of color film to Edward, which he used intermittently for two years. With his father's physical condition deteriorating, Cole loaded up and shot much of the unused film himself. While Edward viewed color photography as a separate, but legitimate, medium, Brett objected outright to the use of color in photography. Cole tells a story of Brett refusing to take off his dark glasses when Cole approached him with photographs made with 8-by-10 Kodachrome film. Years later, Brett grudgingly confessed to seeing some merits in Cole's compositions.

During the 1950s, Cole began to make a name for himself. Now married to his second wife, Helen, and raising four children—Ivor, Kim, Rhys, and Cara—he became a landscape photographer of note, and his images appeared in books, as well as on calendars and on album covers. *Surf and Headlands*, a photograph from 1958, was used for the cover of the Sierra Club book *Not Man Apart*. When the book was serialized in *Reader's Digest*, Cole joked that his work was being seen by "twenty million people sitting on the john." During the 1960s, Cole expanded his photographic

scope, making excursions to deserts and mountains. His first solo exhibition was held in San Francisco in 1971.

In 1974, Maggi Weston, Cole's third wife, a beautiful actress Cole met while directing a play, launched the Weston Gallery, the first photographic gallery in Carmel. Up to this time, Cole's "keeper of the flame" status had not been a lucrative torch for him to carry. Its rewards were largely emotional. In the years immediately following Edward's death, "EW/CW" prints sold for no more than $50 apiece. To Cole's and Maggi's benefit, the fine-arts photography market began a vertical ascent.

Because Cole stopped printing his father's negatives in 1988, there are final prints—the last remaining Edward Weston negatives printed by Cole—which go for a considerable sum. Edward's own prints are worth more still. "It is amazing what has happened," says Maggi Weston "I never would have expected the market to go this far this soon." Moreover, as color photography has gained respect as a legitimate art form, Cole's own images command high prices.

Cole's role in preserving and transmitting Edward's place in photography mustn't be overlooked. Drawing from his theater background, Cole gave workshops internationally on Edward Weston, teaching in such places as New Zealand, Holland, and the former Soviet Union.

At numerous exhibits over the years, his pictures have been put side-by-side with Edward's, and the two generations have been joined occasionally by a third—Cole's second-born, Kim, who lives with his family in Edward's old Wildcat Hill house in Carmel Highlands. Kim has no desire to compete with his celebrated father, uncle, or grandfather, but an inherited passion propels him to wake up most mornings at 3:30 A.M. to work in his studio. "A world without photography is like a world of darkness," he says. Like his father, he follows his heart. With Brett Weston's death in January 1993, the "Weston legacy" (Kim chuckles at the term) has fallen clearly to Cole and Kim.

THE HEART FINDS ITS SUBJECTS

A bird's-eye view takes in half a dozen or so actors listening to a white-bearded director in front of a barn somewhere in Salinas, a half hour's drive east from Carmel,

California. Here amid the smell of hay and the clucking of chickens, they stand in the heart of "Steinbeck country," doing an off-stage rehearsal for *Of Mice and Men*.

Hamish Tyler, a soft-spoken fellow director and Weston protégé, finds one of his favorite subjects in Cole Weston. Tyler says he has been influenced deeply by Cole's insistence that art not just imitate life, but be felt as strongly. His mentor's casting choice of Henry Littlefield, the headmaster of a local prep school, a Ph.D., and one of the most intelligent fellows around, was an inspired choice for the role of the mentally handicapped Lenny. Cole must have been drawn to Littlefield's hulking frame, a match for Lenny. Cole never seems more like a photographer than when he is directing. To him, a play is more than action and unfolding relationships; it is a "look," a series of rolling compositions—the ultimate photo essay.

Cole has described his three loves in life as theater, photography, and sailing. With his energy diminished but still considerable, Cole has given up two of the three: photography remains.

Passion has been the guiding force in everything Cole has done. At the Forest Theater, he has directed thirty plays. His list of accomplishments over half a century ranges from designing and building an indoor theater to leading a successful effort, in the early 1970s, to stop the city from turning the theater into a corporation yard.

As for sailing, it represents freedom, self-reliance, and the quest for beautiful sights. Buying a fifty-foot, Dutch-built, steel ketch, *Scaldis*, in 1968 charted a new course in his life at a time when he felt adrift. He was serving as Carmel's first Cultural Department manager, a post which gave him a newfound financial security but an inescapable feeling of restlessness. When the Cultural Commission refused to grant him a year's leave, he quit and took his family on a seven-month voyage.

Cole's passion for sailing was shared with his brother Neil, whose well-being was so nurtured by the sea that even his notorious migraines couldn't reach him offshore. As young men, Cole and Neil built a thirty-two-foot boat by hand. Such mechanical gifts were a Weston trademark. Chandler (who died in 1993) revealed his through a lifetime as

an inventor. Neil, who made a career of building boats and houses, played matchmaker by bringing Cole and *Scaldis* together.

One of the achievements Cole takes greatest pride in is his command of navigation. His destinations over the years have included Central America, Mexico, South America, Jamaica, Bermuda, the South Seas, the Galápagos, Marquesas, and Tahiti. "Removed from the props of civilization, he gained insight and perspective," remarks longtime sailing partner Leland Lewis.

It would be negligent to omit Cole's fourth true love in life: women. He has been married four times, and, in between, has enjoyed a long succession of lovers and longtime steadies. According to Deborah Smith, who lived with Cole during the 1970s and assumed the name Deborah Weston during that time, Cole was a "tremendous romantic" who delighted in the rituals of courting. Both Maggi Weston and Deborah Smith say that Cole carries on warm, devoted friendships with the women of his past, and they continue to count themselves among his greatest admirers.

Cole's wife, Paulette Weston, another much-younger woman, laughs about Cole's charisma around women. She'd be the first to tell you about those women who are all too eager to drop their clothes at the merest suggestion that a nude would be "just the thing." Paulette says that "These women just come out of the woodwork. Part of it is that they just trust him."

Paulette, herself a photographer, can enjoy the company of her husband at a rare point in time; his life revolves around only photography and her. Fifty years after Cole bought the land at Garrapata, the couple occupy three buildings a mile inland from the coast. The main house is raised from the ground and a creek flows under it. Cole's son Matthew occupies a separate living unit. Cole's 20-by-20 studio is three times the size anything Edward squeezed into. Since the late 1970s, he has used the most sophisticated equipment available to make his prints—a one-ton Salzman enlarger fitted with a Super Chromega Dichroic color head.

While Cole admires his wife's photography, Paulette, a vivacious woman whose accent hearkens back to her native Alabama, acknowledges that she is still learning from Cole.

In their travels, the couple have an informal agreement: don't shoot the other's subject. Every rule is meant to be broken. Cole, on a 1994 trip to England, begged Paulette to let him return to a greenhouse that had earlier captured her fancy. Paulette says of this shot, included in this collection as "Greenhouse, Bradbourne, England," that it was better than hers because Cole thought to focus in on just the right detail, rather than on the entire window.

Deborah Smith remembers Cole's spontaneous, carefree ways on their trips to places like Alaska, Nova Scotia, and New Zealand. "He'd see something he liked and we'd stop. We'd get out and look around, and there might be something of interest—maybe an old window to look through. I personally didn't have any qualms about taking my clothes off, so we could have a nude in the shot."

Cole's approach to photography is characterized by openness to inspiration. His work is fresh, spare, uncluttered. "From Cole, you just get the guts of the thing without any manipulations," observes Al Webber, a Carmel photographer who met Weston in the 1950s. Weston's focus on the landscape may strike some as too traditional. But Webber stresses that "On the East Coast, they might think the straight landscape is dead, but on the West Coast, we don't buy that. You won't hear it from people like Cole, who were raised next to places like Point Lobos."

There is nothing labored in Cole's search for images. In his travels, there are days when he shoots only one or two negatives, if that is all that he is inspired to do. In a sense, he has opened himself up to two legitimate points of criticism, which can be framed as questions: First, is it less admirable to go after a conventionally beautiful image, rather than to attempt "higher" art? Second, does Cole's photographic work meet his standards for theater? Is it "photography with balls?"

Cole's response on both counts is that his photography works on purely emotional, dramatic, and aesthetic planes. The lasting value of his pictures is that the viewer, ten, twenty, or thirty years later, can still experience what the photographer felt when the shutter fired. "If it moves me, I photograph it. If I see it as very beautiful, others are liable to as well. I don't think there is anything wrong with that."

This volume includes some of the best images from Cole's long photographic career. At the top of anyone's list is *Surf and Headlands*, taken on a blustery day in early 1958. It has been described as the definitive meeting of ocean and land. The crashing wave matching the shape of a rock in the distance is grace itself. In a rare case, Cole actually shot several negatives at 1/100 of a second, recognizing the infinite ways in which waves can break. It is both his greatest and his luckiest image, the convergence of time and skill. "It was absolute luck. It is my *Pepper #30*," he says, attuned to the paradox of the statement.

Palo Corona Ranch, also included in this book, is another glorious example of those elements he both will and will not take credit for. Cole had driven by the ranch, just south of Carmel, on hundreds of occasions, but this time the light and the placement of the cows grabbed him. "People have tried and tried to photograph it, but it will never, ever be that way again," Cole reflects. "Now they have black-and-white cows. There are feeders down there. You won't get the clouds right, and the sun exactly there."

The picture is a glimpse of the power of color. With black-and-white film, the glowing green of the ranch would have been an uninspiring range of grays. "That picture shows how Cole can take seemingly mundane subject matter and really do something with it, make something special out of what most people would pass by," observes Henry Gilpin, a Monterey-based fine-arts photographer. In all his work, Cole takes the technical precision he learned early and applies it to his own unique vision. Cole's pursuit of color itself has served as the perfect vehicle for his finely honed craft and unique form of self-expression.

WE MUST SEE, WE MUST DANCE

To this day, a snapshot is lodged in the memory of Gordon Miyamoto, a lifelong Carmel resident: Edward standing with a tripod on his shoulders, accompanied by his eleven-year-old son, Cole, surveying the harvest of cabbages, turnips, carrots, beets and strawberries from the Miyamoto's farm. Edward got most of the vegetables for his still-lifes from the farm. Sometimes, he would set up his tripod and compose a shot right there.

The Weston legend is a tale of an extraordinary family living in an extraordinary region. The Weston gift is the capacity to see beyond the surface of the ordinary. The vegetables were there for anyone to discover. So was Palo Corona Ranch. Whether discussing his father's work or his own, Cole maintains a constant theme—that of "seeing" and improving the "ability to see." Cole's aim has always been to add a strong dose of feeling to the mix.

Theater may have been his first love, but photography is his most enduring. It wooed and won him. There was, to be sure, a feeling of familial obligation that Cole couldn't ignore. But his love of the medium grew steadily throughout his full life.

Cole once found a passage that Edward scrawled out: "We sweat and groan that we might buy tickets to have some other person dance for us when we should dance—or sing when we should be singing." Cole says the words still inspire. It seems too fitting that, back in his Cornish School days, he was an accomplished dancer. Captured in photographs are images of him gyrating in a tango and whirling about in the latest dance steps.

Edward's message, of course, was not literal but metaphorical: we must dance to live. Cole Weston has never stopped for a minute.

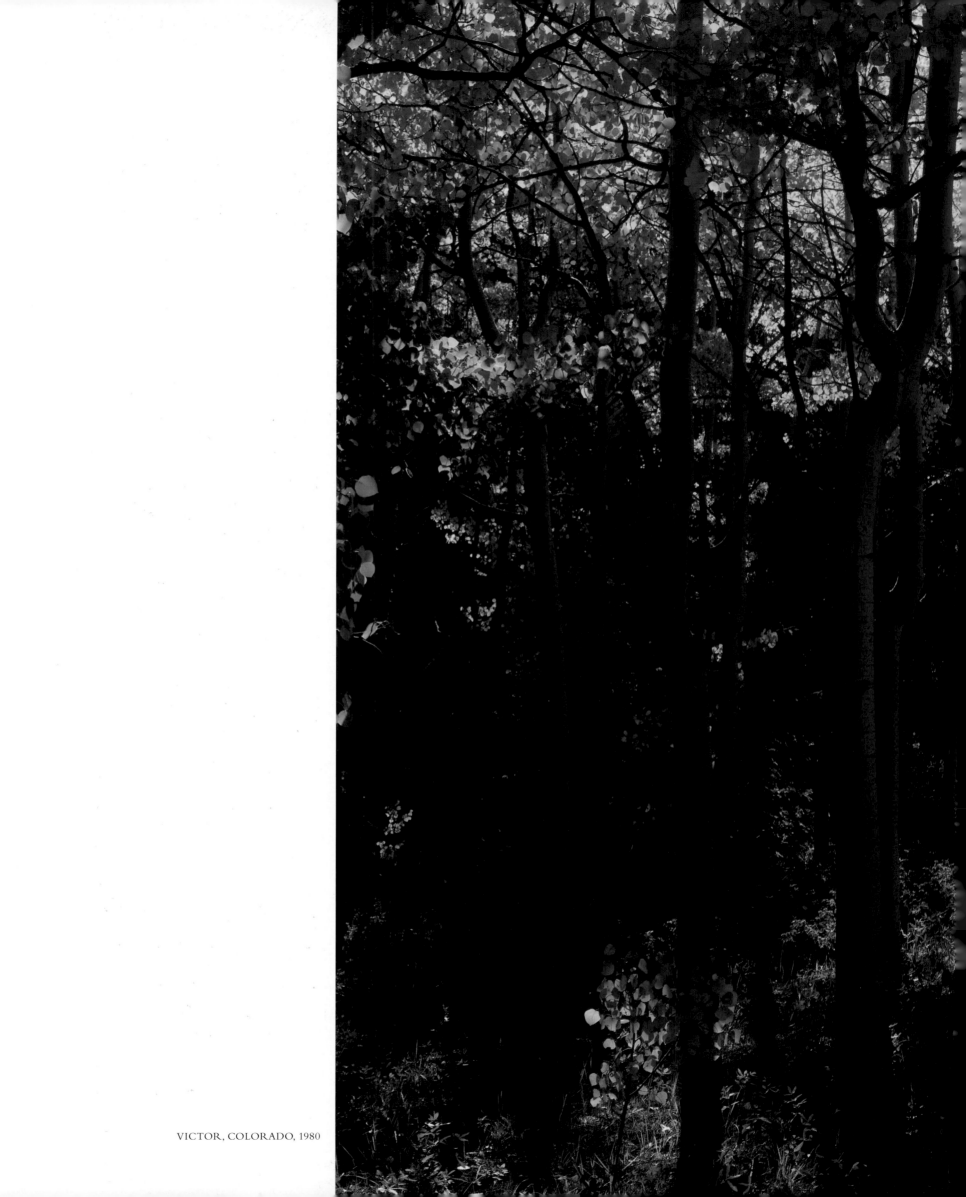

14 VICTOR, COLORADO, 1980

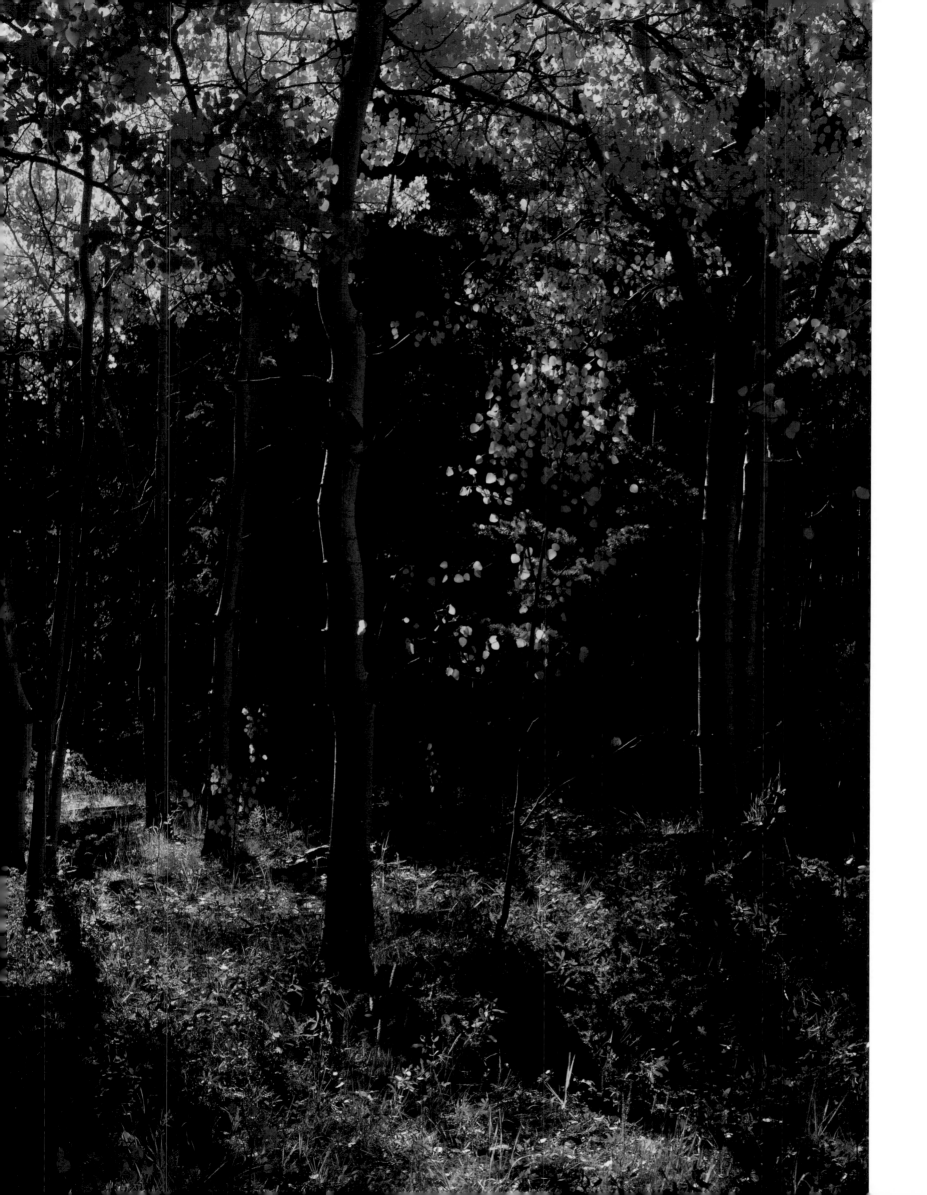

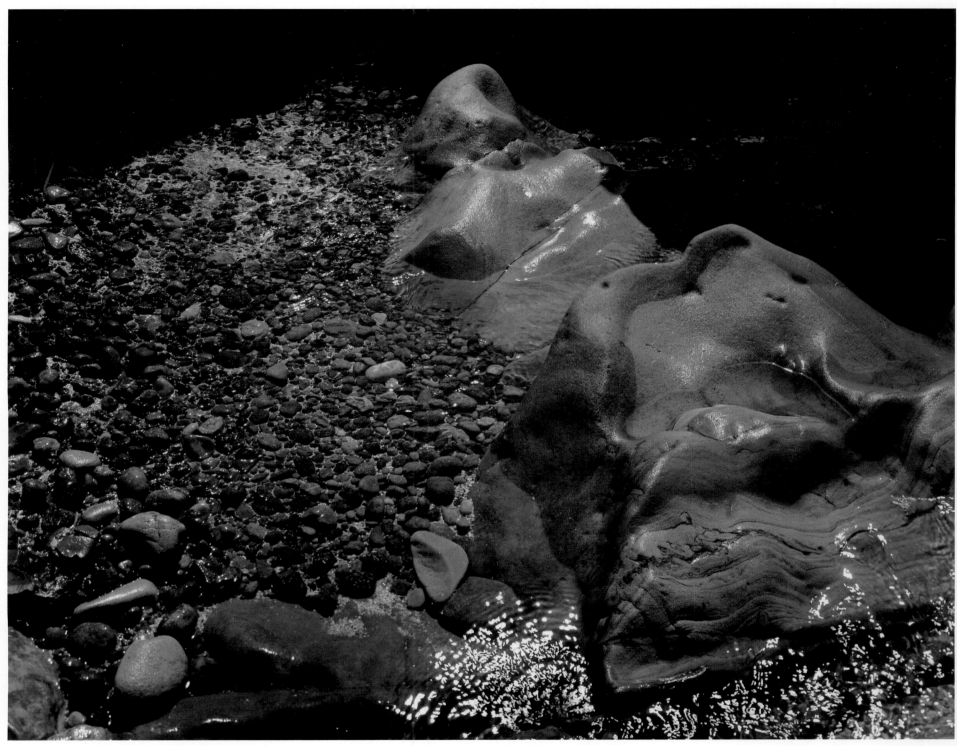

TIDE POOL, POINT LOBOS, CALIFORNIA, 1970

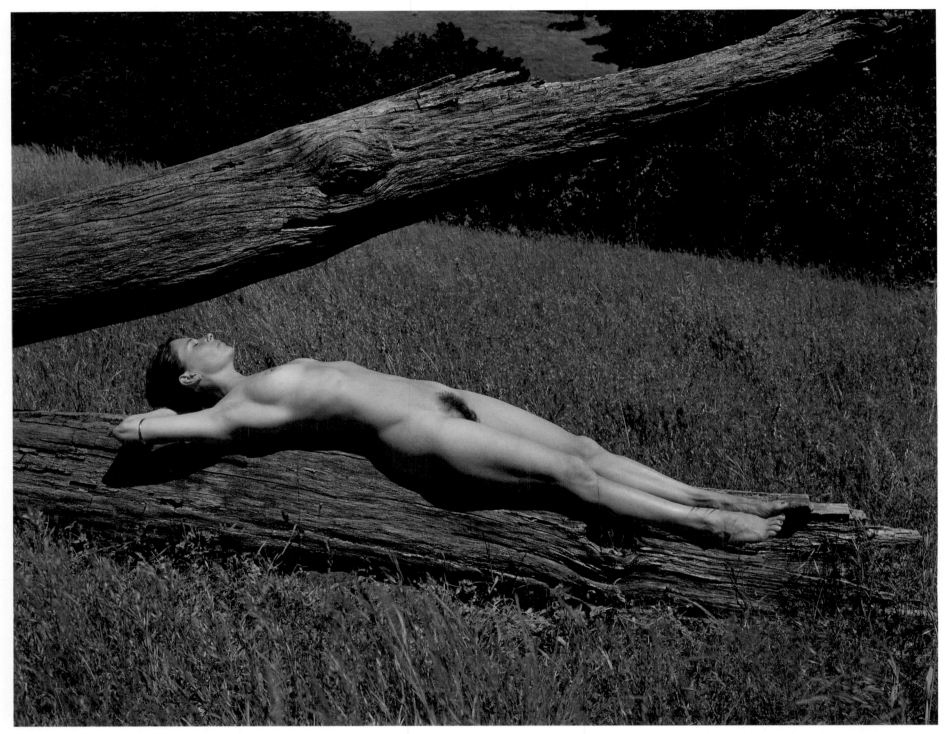

NUDE, CARMEL VALLEY, CALIFORNIA, 1978

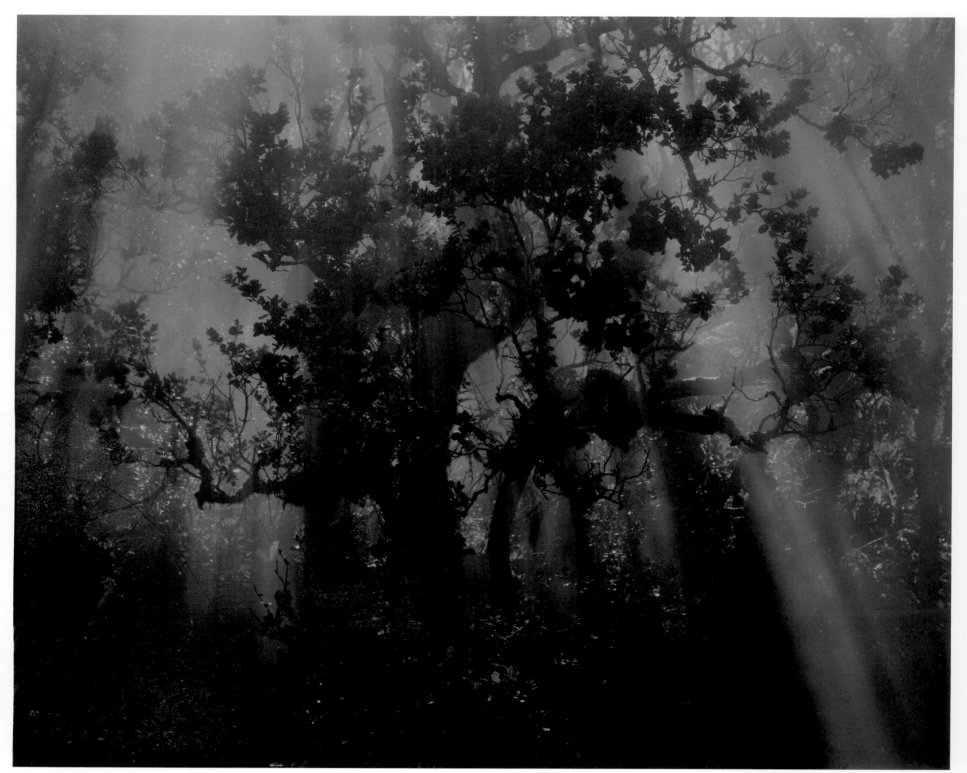

VOLCANIC MIST, HAWAII, 1980

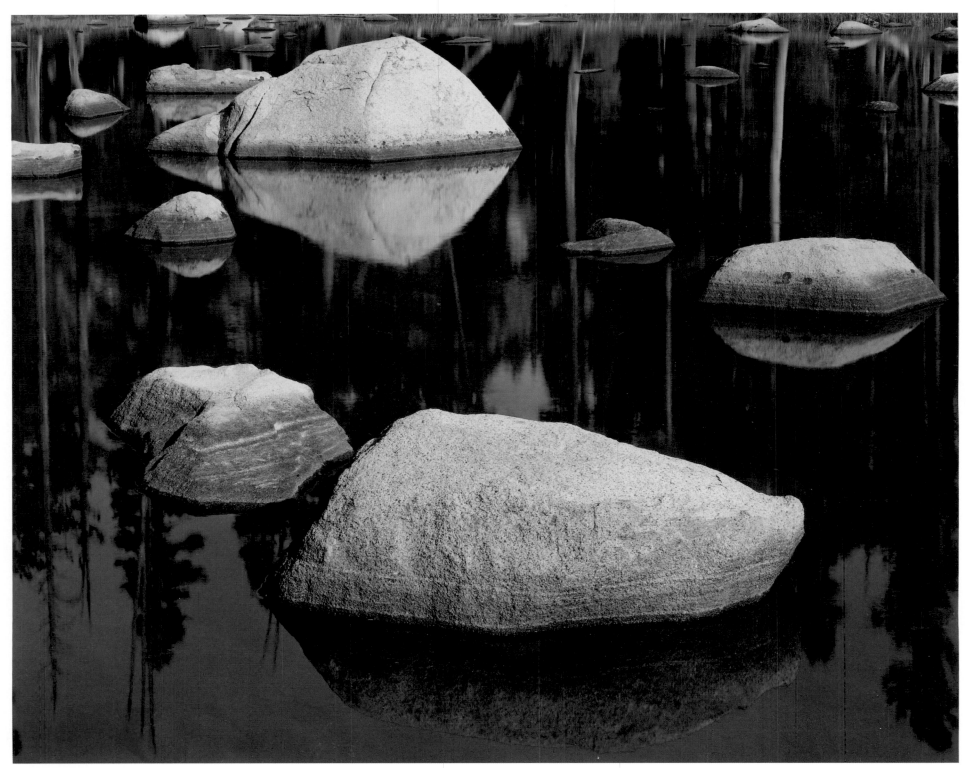

LAKE, YOSEMITE, CALIFORNIA, 1977

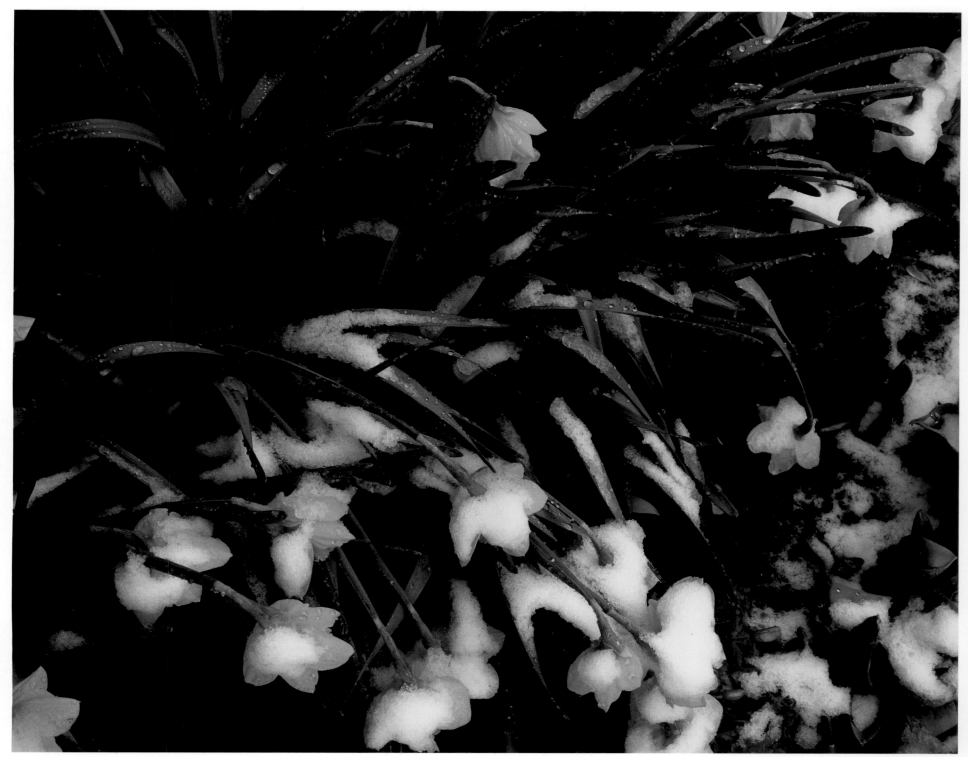

DAFFODILS, CALIFORNIA, 1990

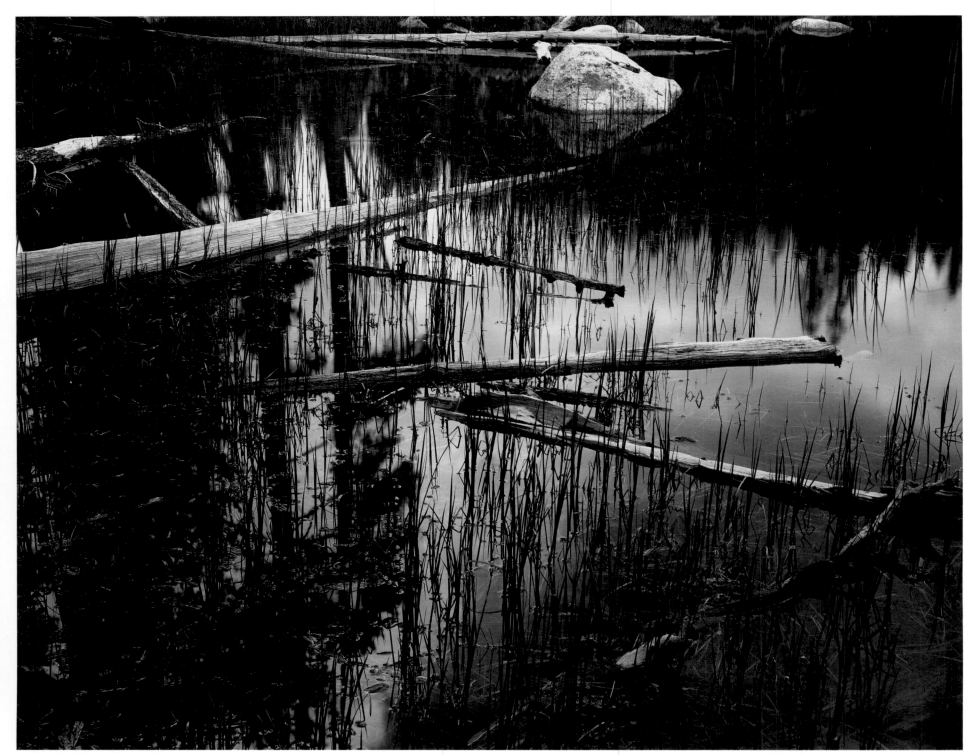

YOSEMITE LAKE, CALIFORNIA, 1983

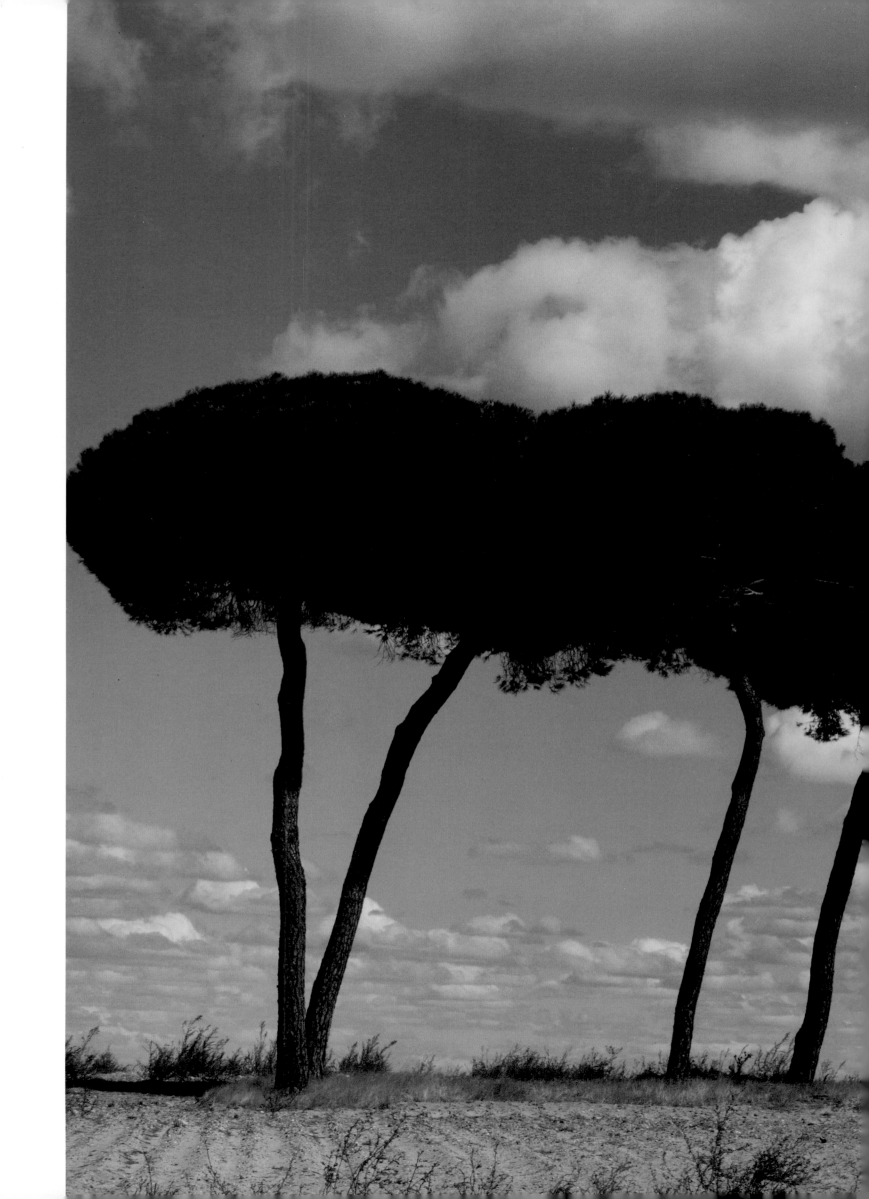

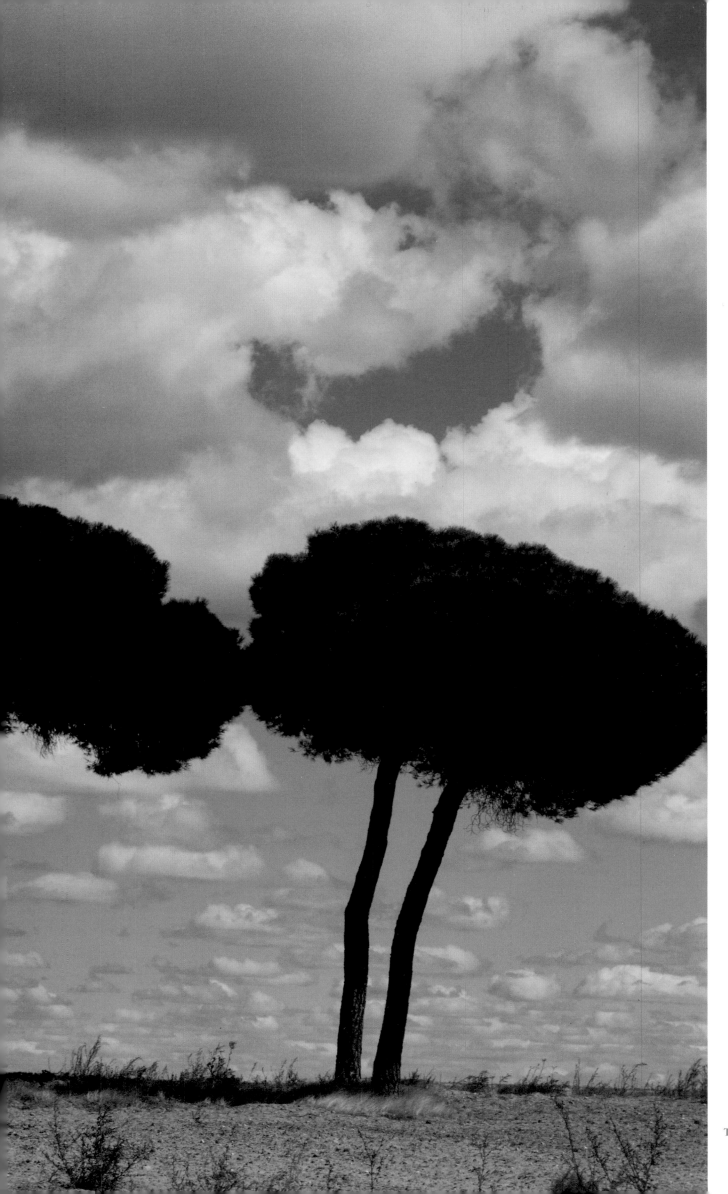

TREES, SPAIN, 1994 23

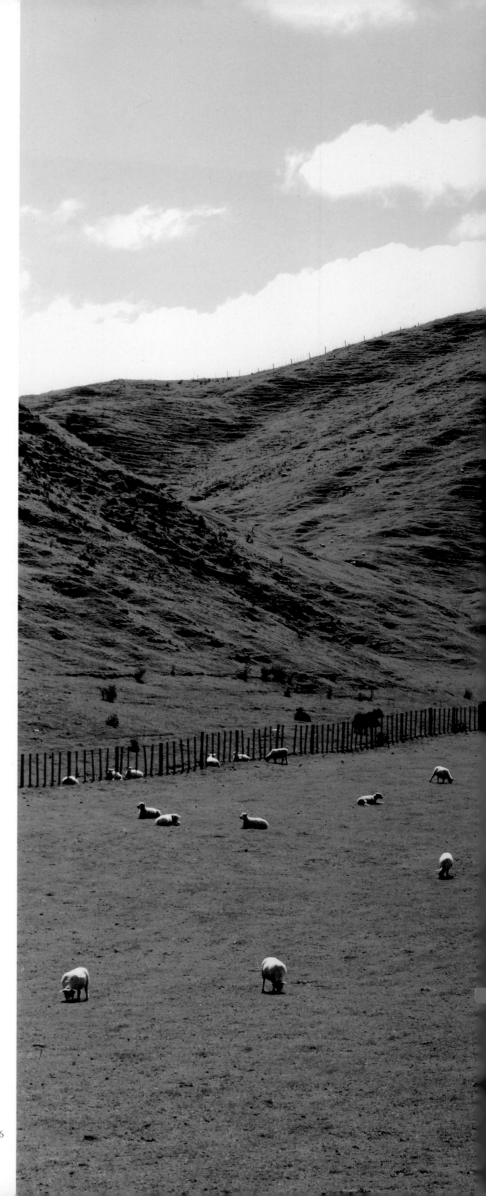

WAIOTAPU, NEW ZEALAND, 1976

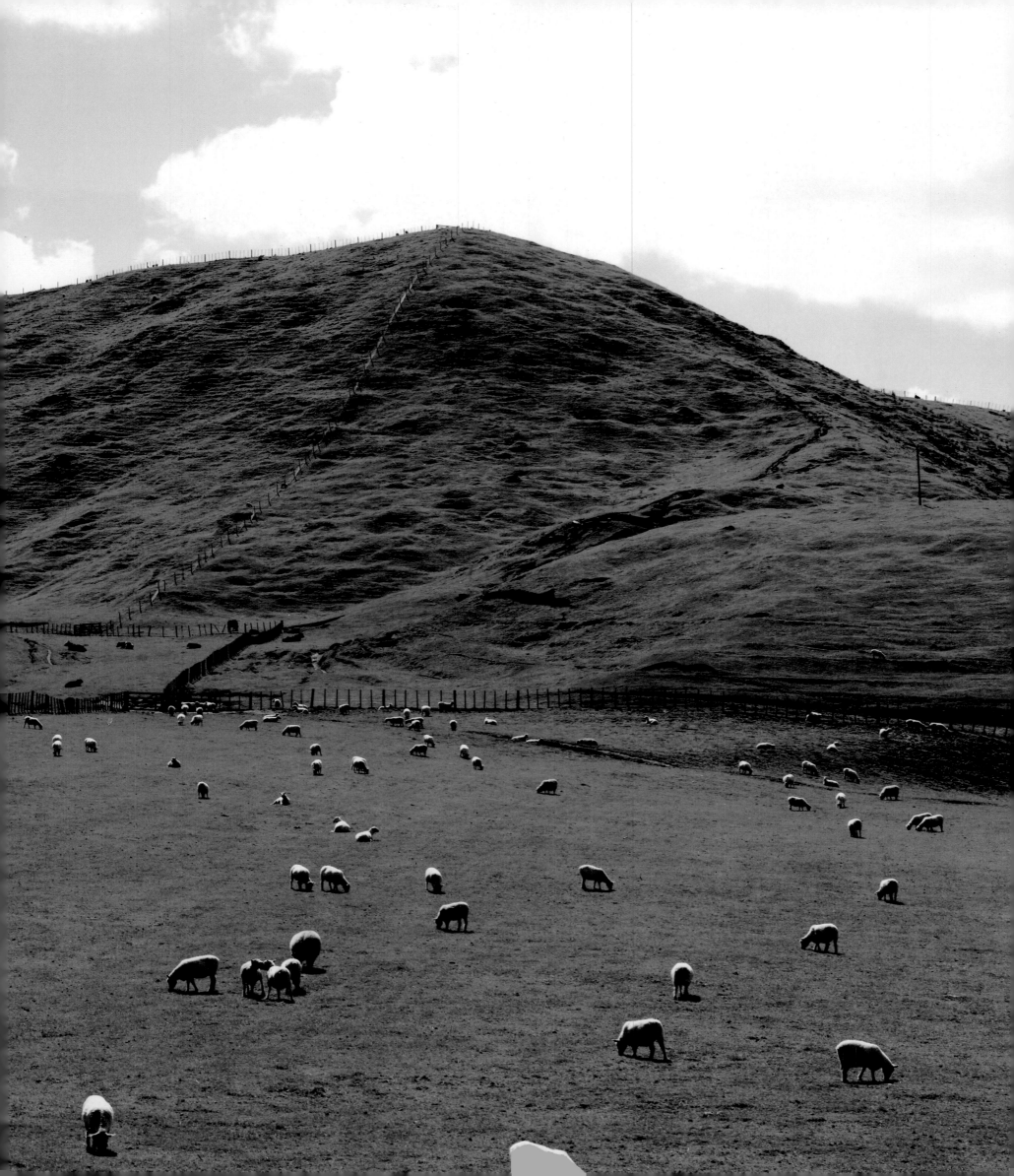

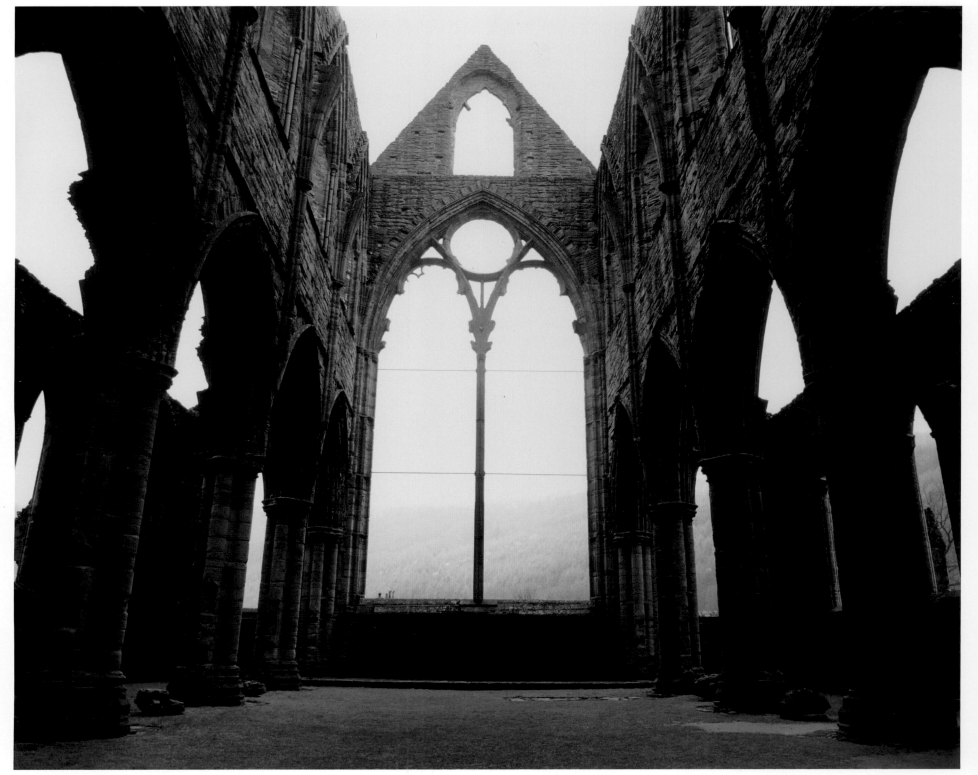

TINTERN ABBEY, WALES, 1996

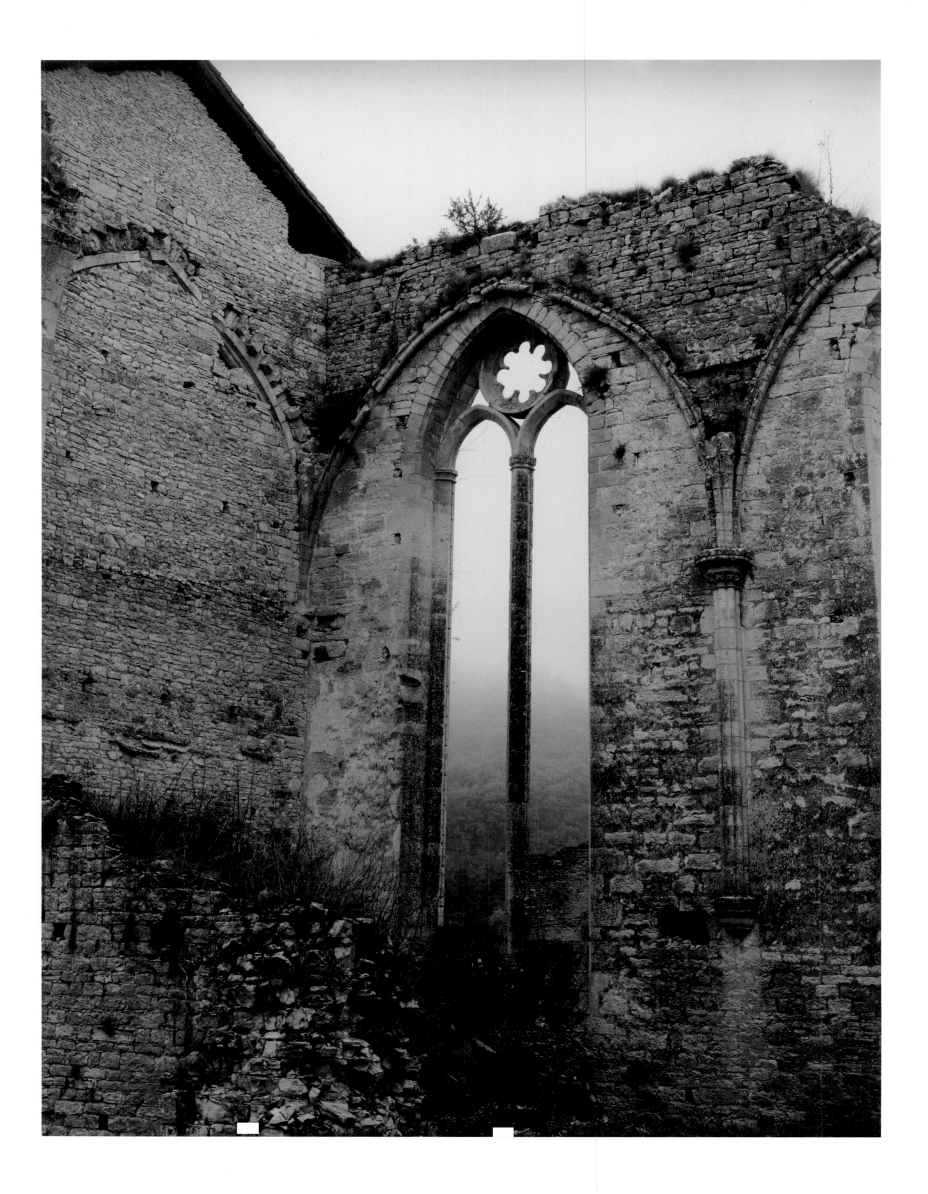

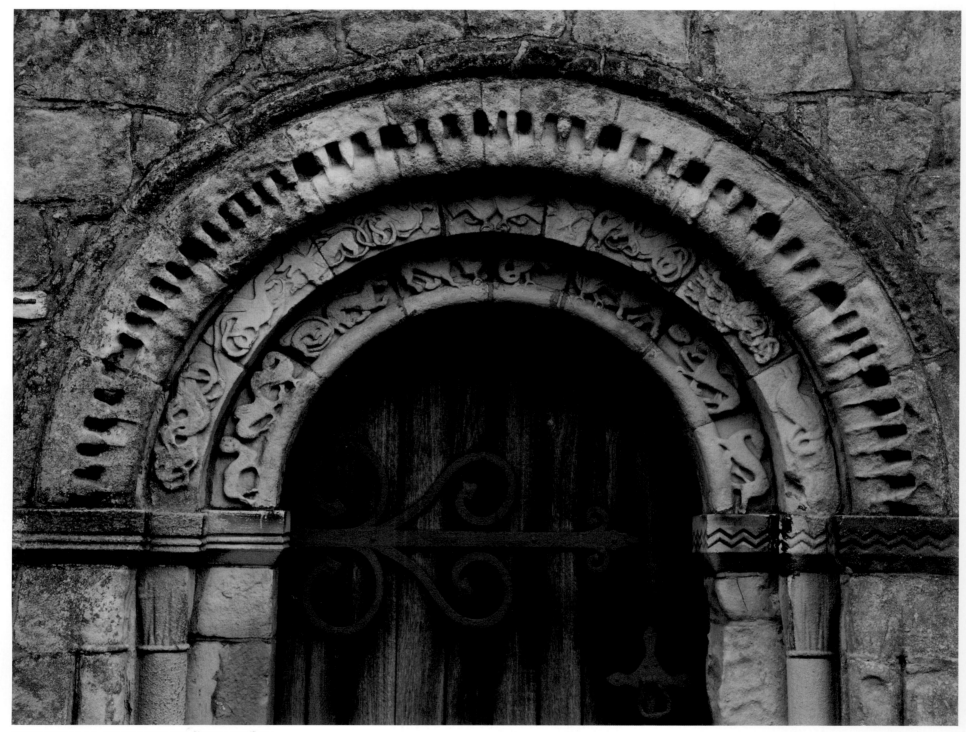

CHURCH DOOR, BRADBOURNE, ENGLAND, 1994

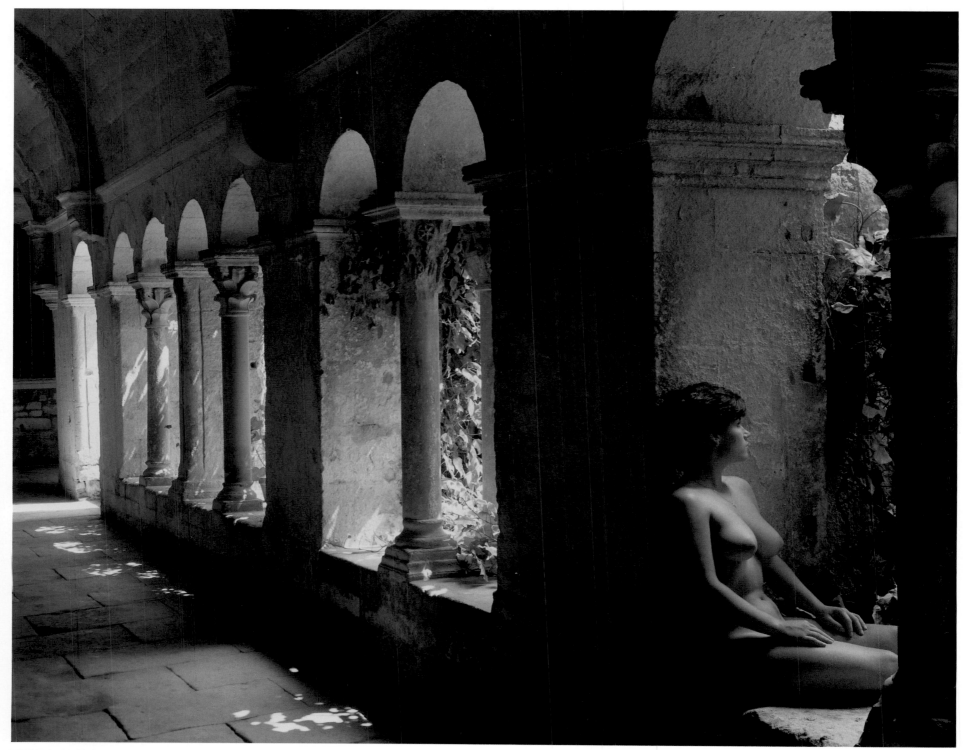

NUDE AND CLOISTER, FRANCE, 1983

30 CAMPGROUND, WALES, 1994

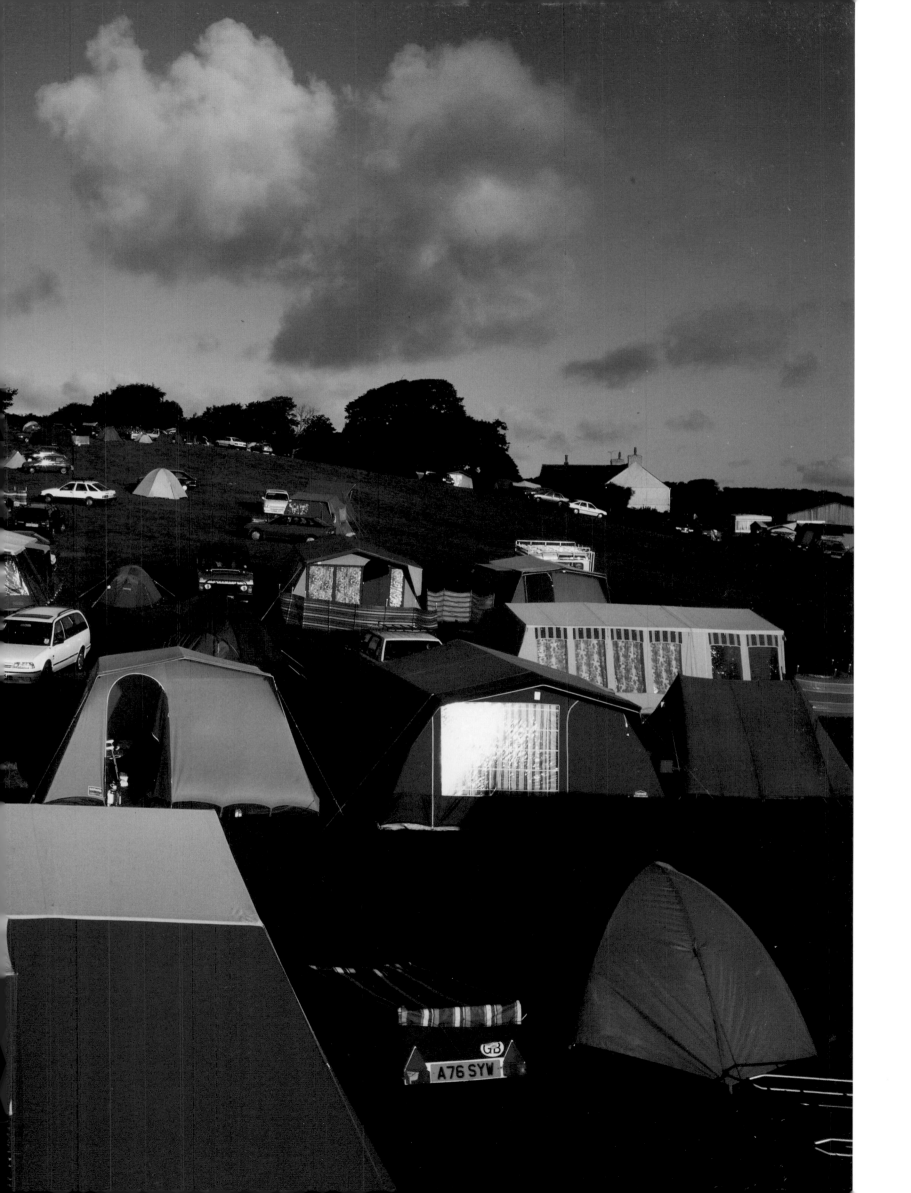

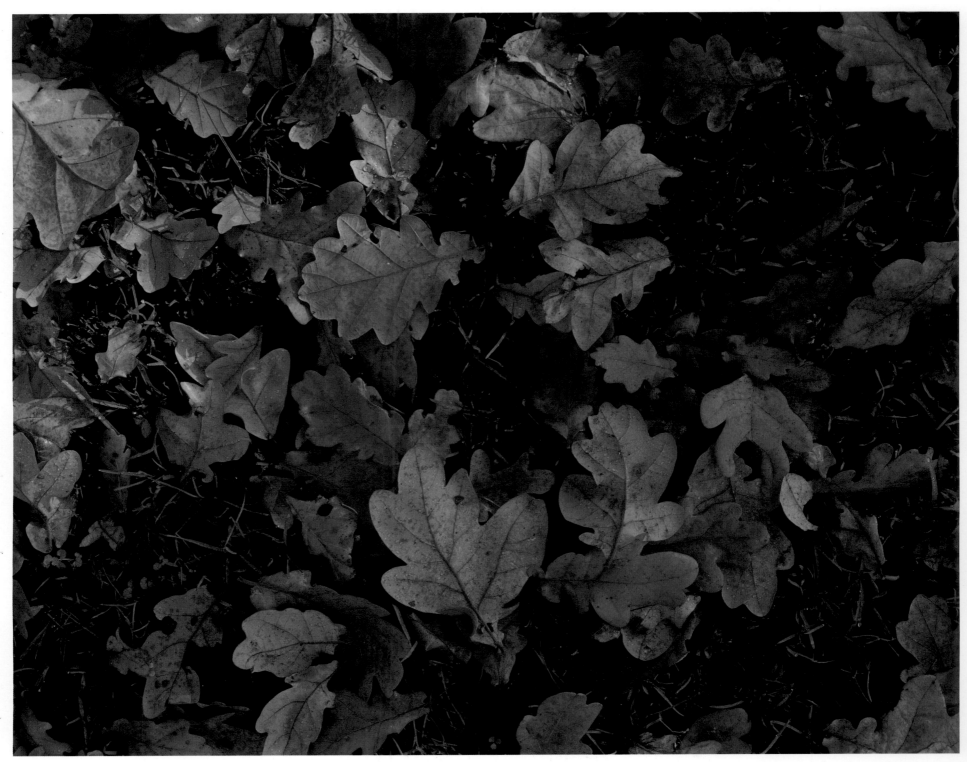

LEAVES, HOLLAND, 1994

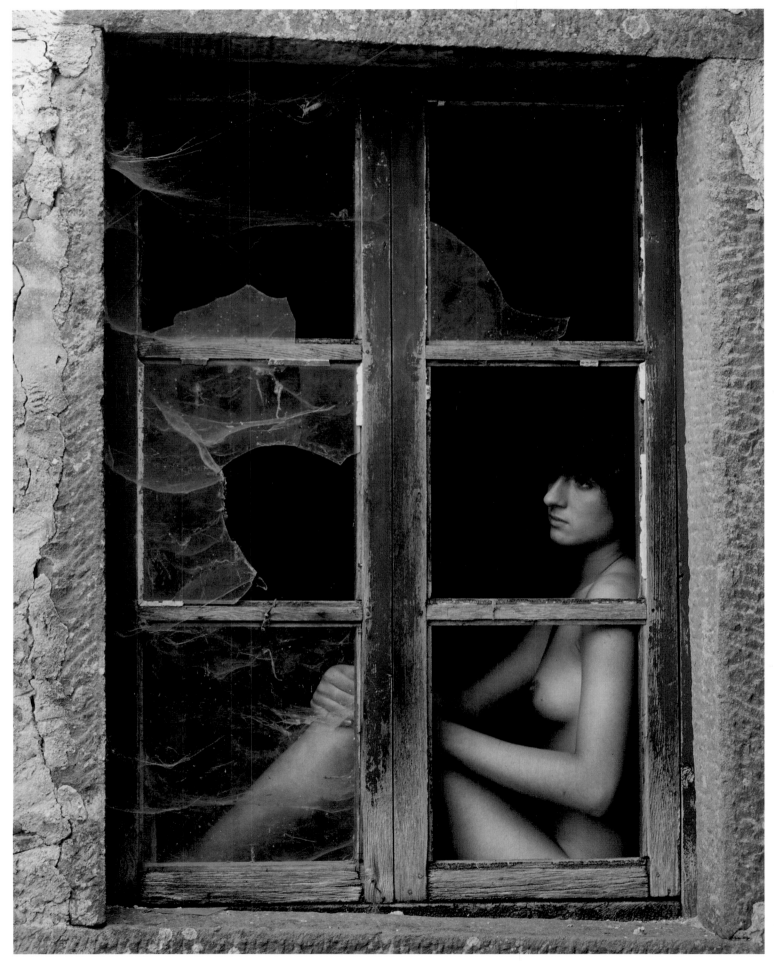

NUDE, ITALY, 1984

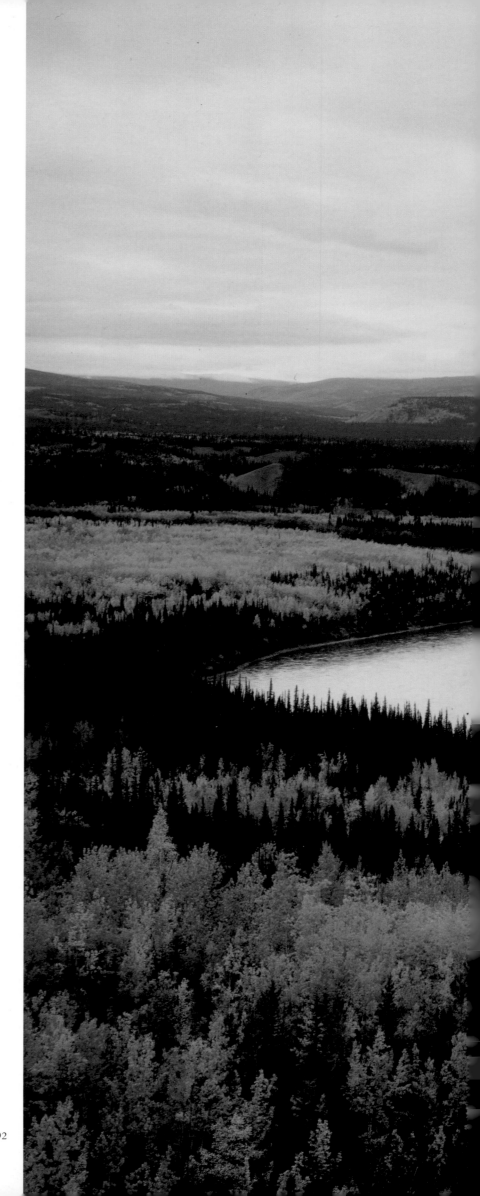

YUKON RIVER, ALASKA, 1992

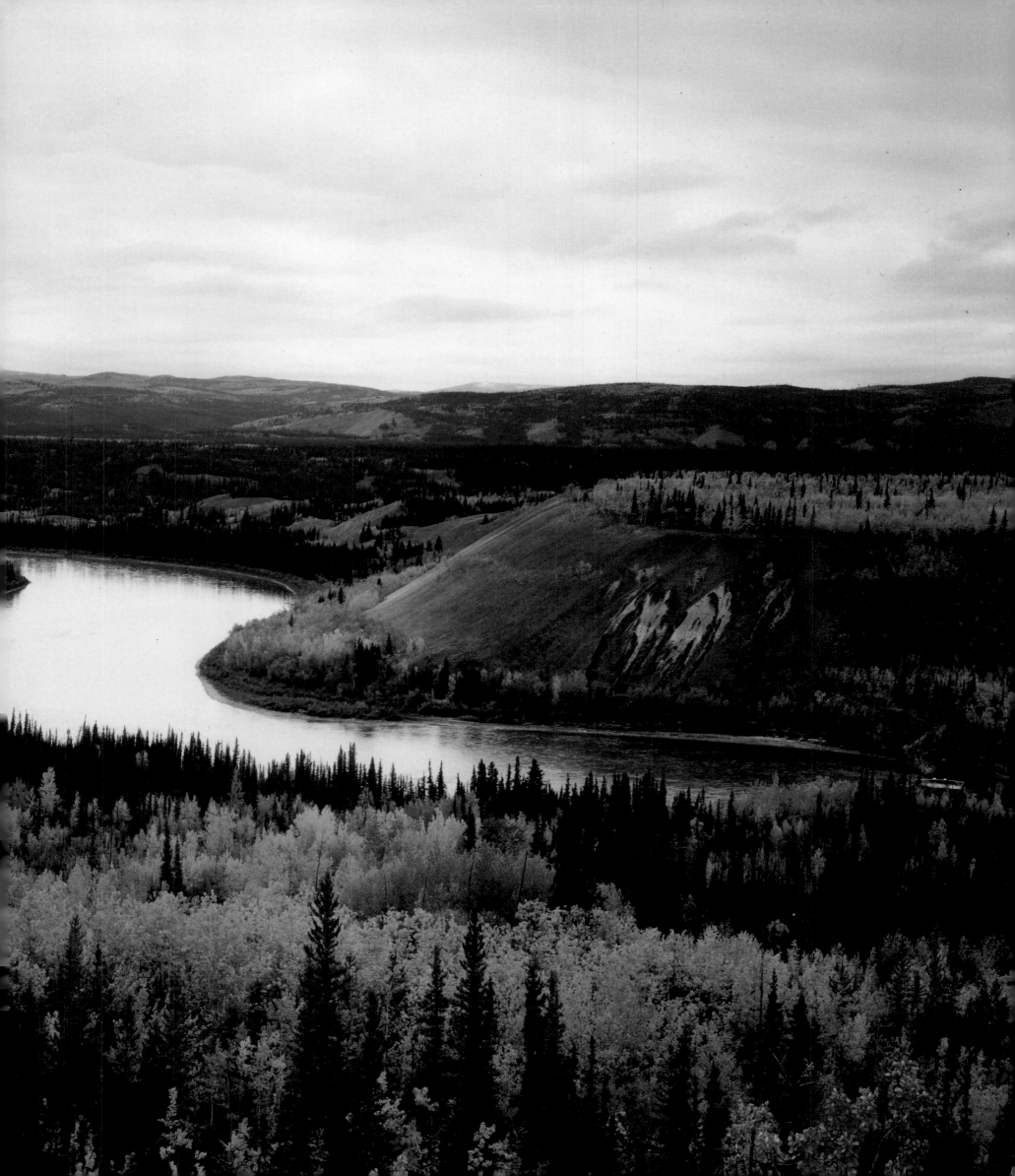

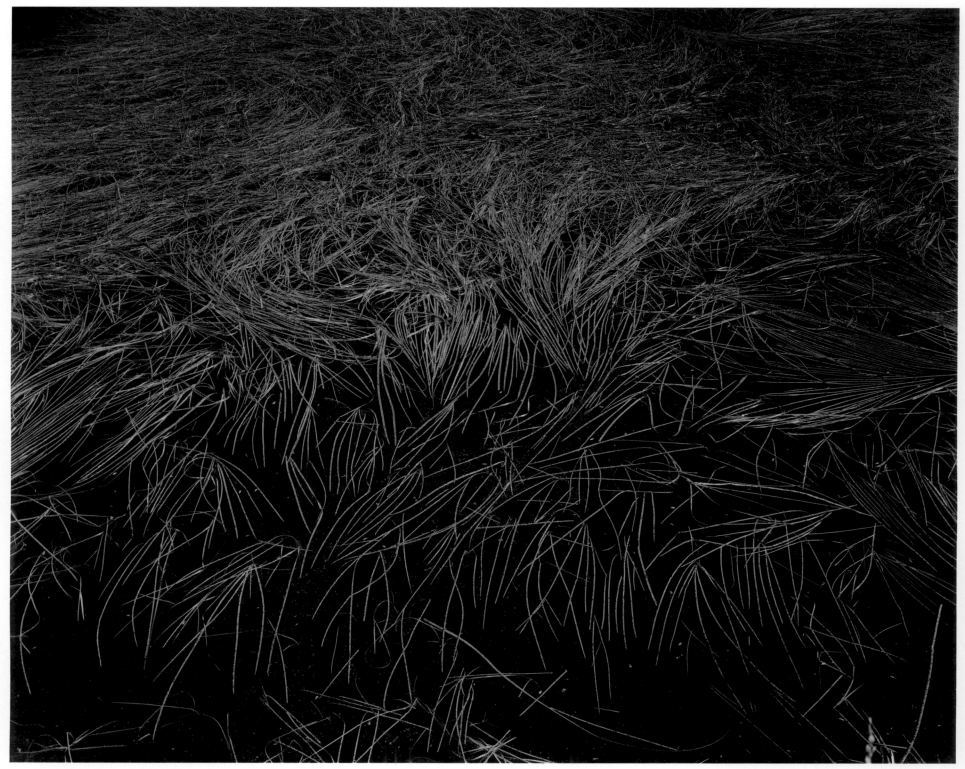

POND, CAPE SABLE, NOVA SCOTIA, 1978

WATERFALL, BRITISH COLUMBIA, 1975

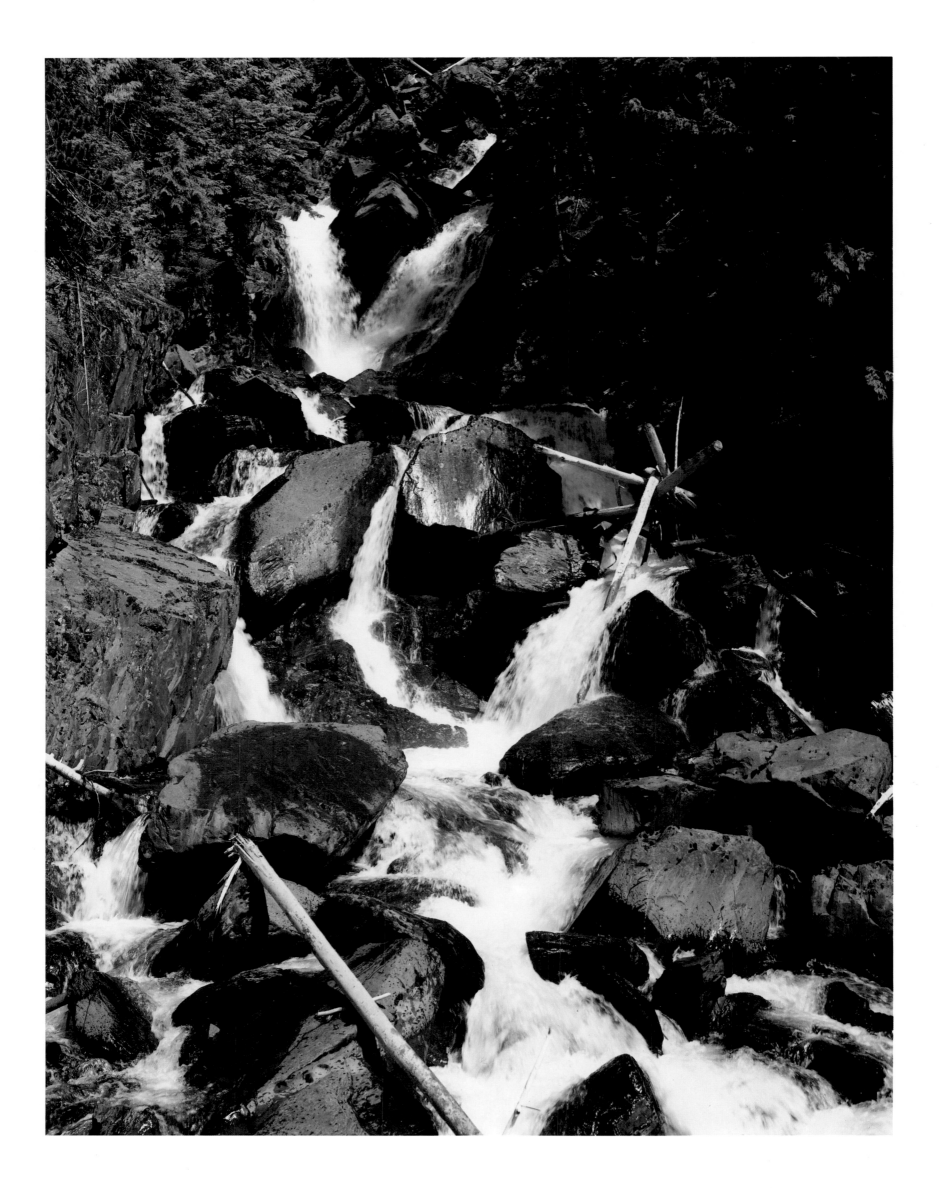

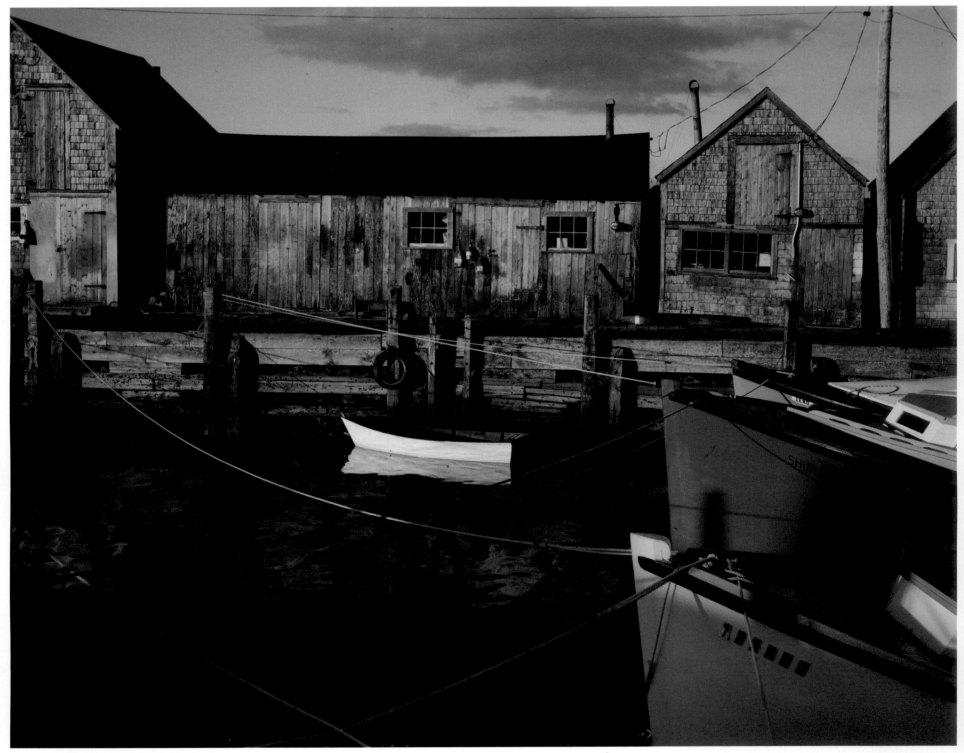

HUNTS COVE, NOVA SCOTIA, 1978

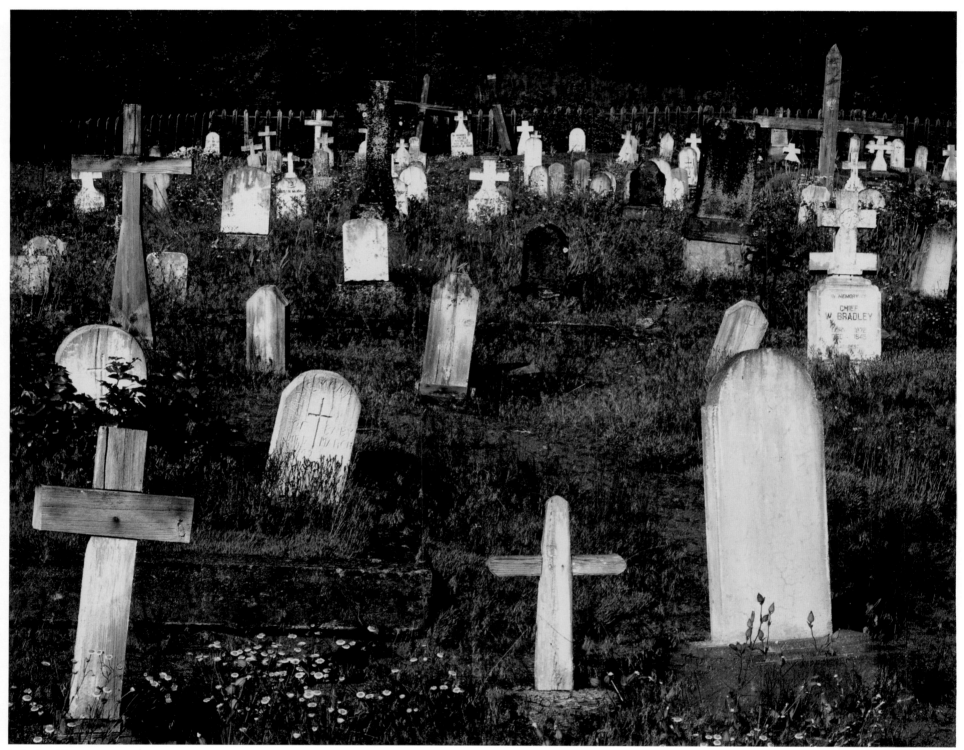

INDIAN GRAVEYARD, CANADA, 1990

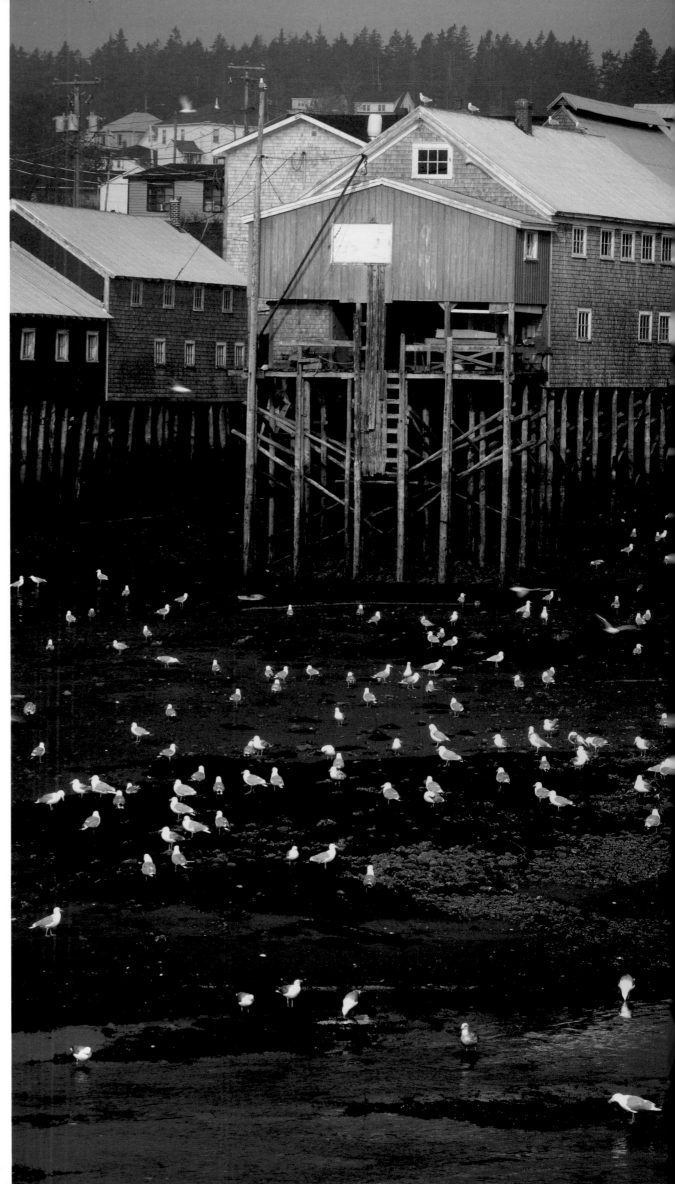

SEAL COVE, GRAND MANAN ISLAND,
CANADA, 1993

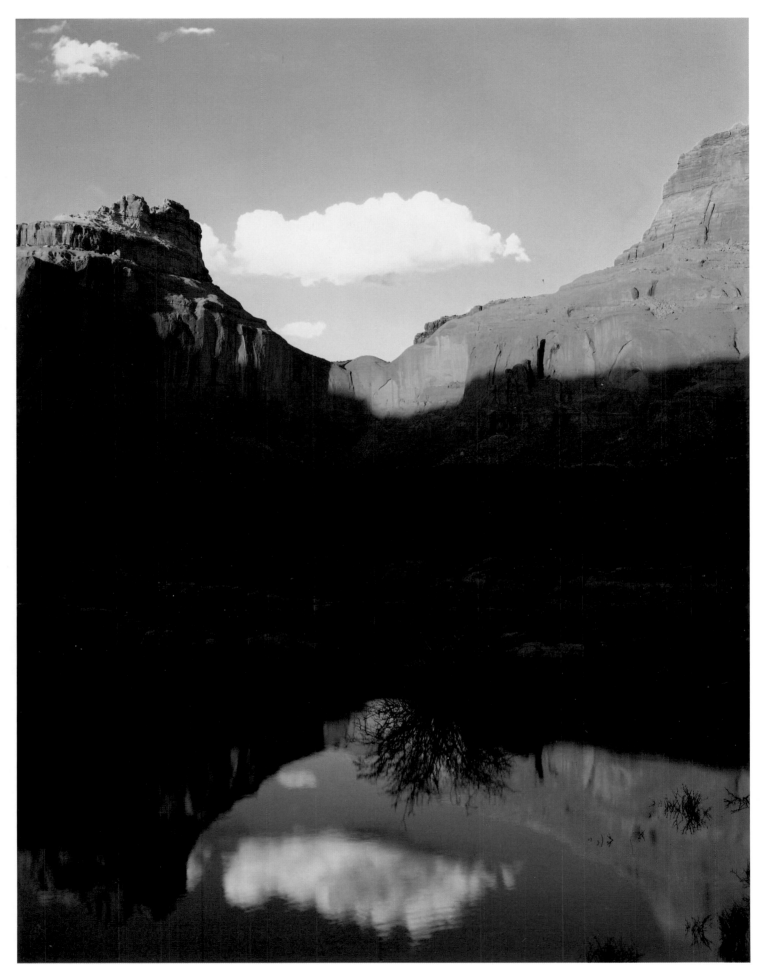

ROCK CREEK, LAKE POWELL, UTAH, 1976

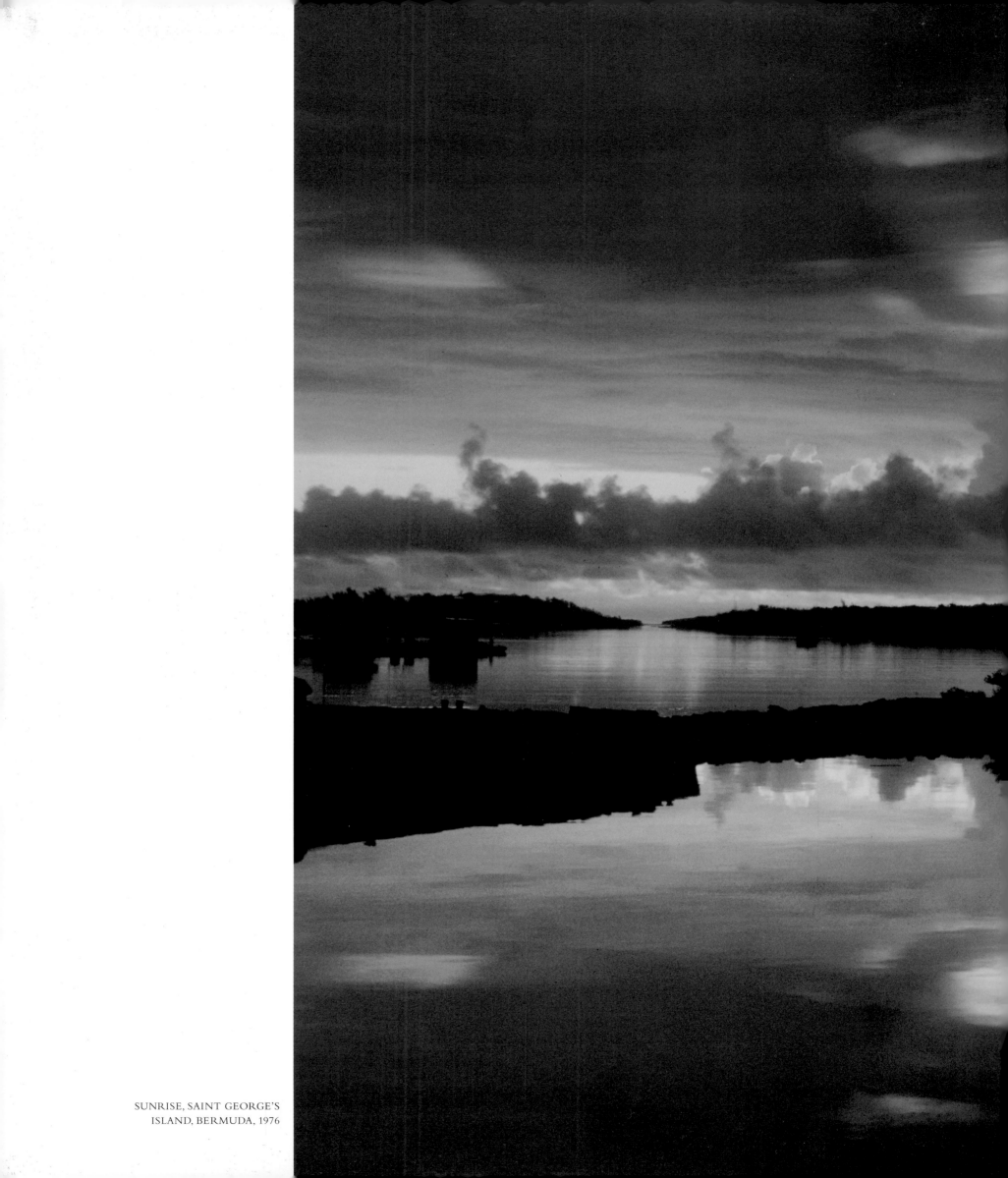

SUNRISE, SAINT GEORGE'S
ISLAND, BERMUDA, 1976

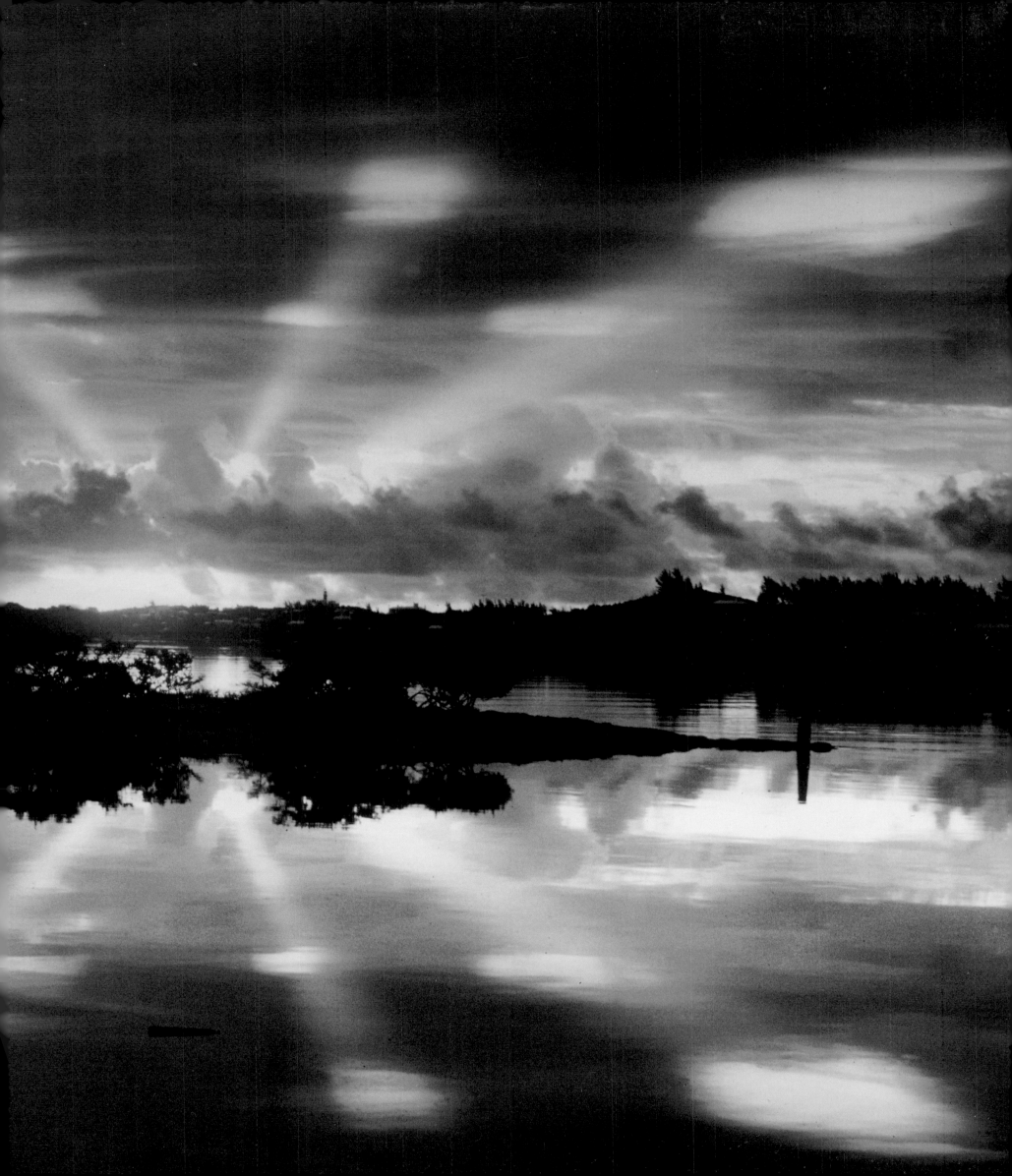

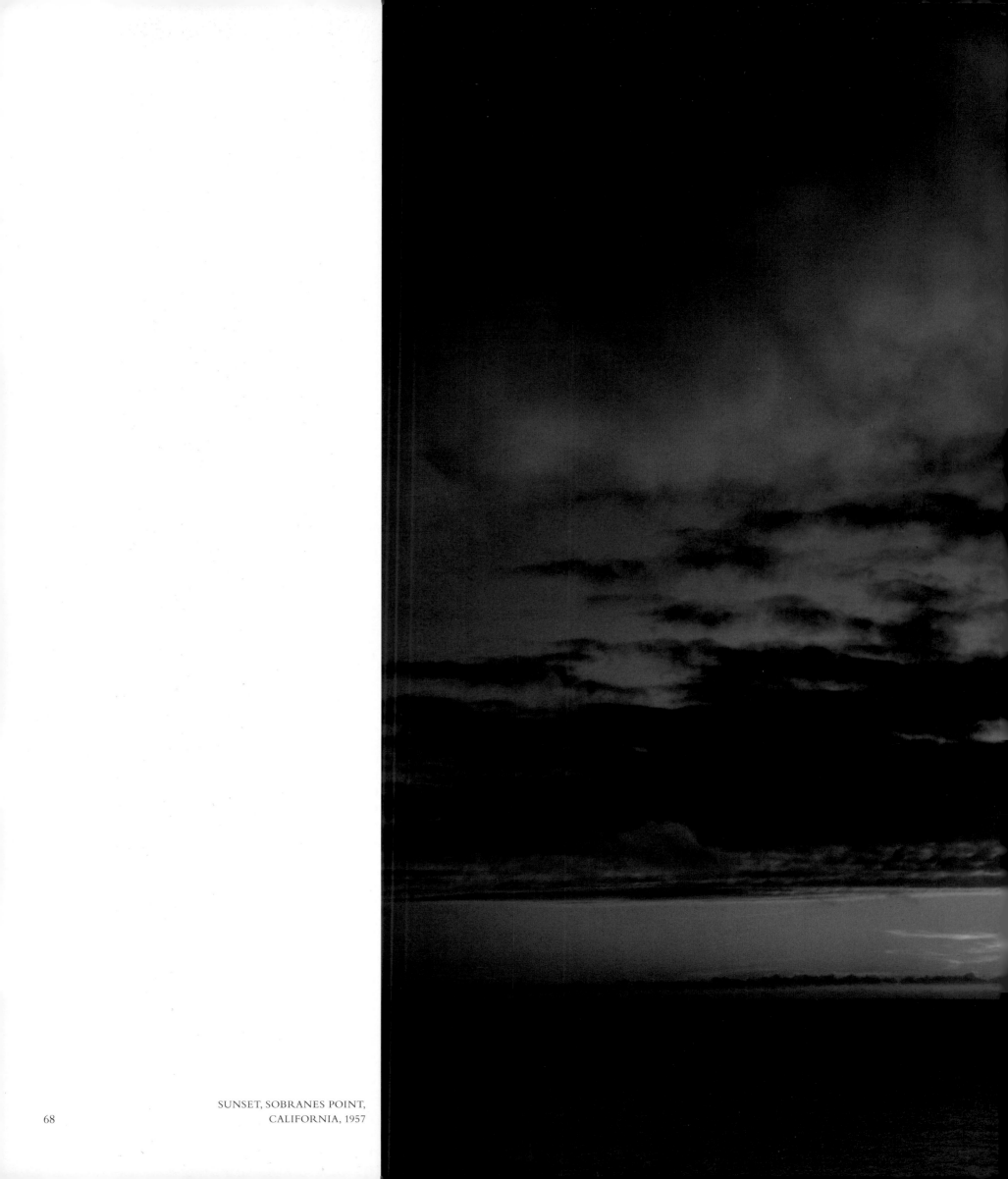

SUNSET, SOBRANES POINT,
CALIFORNIA, 1957

68

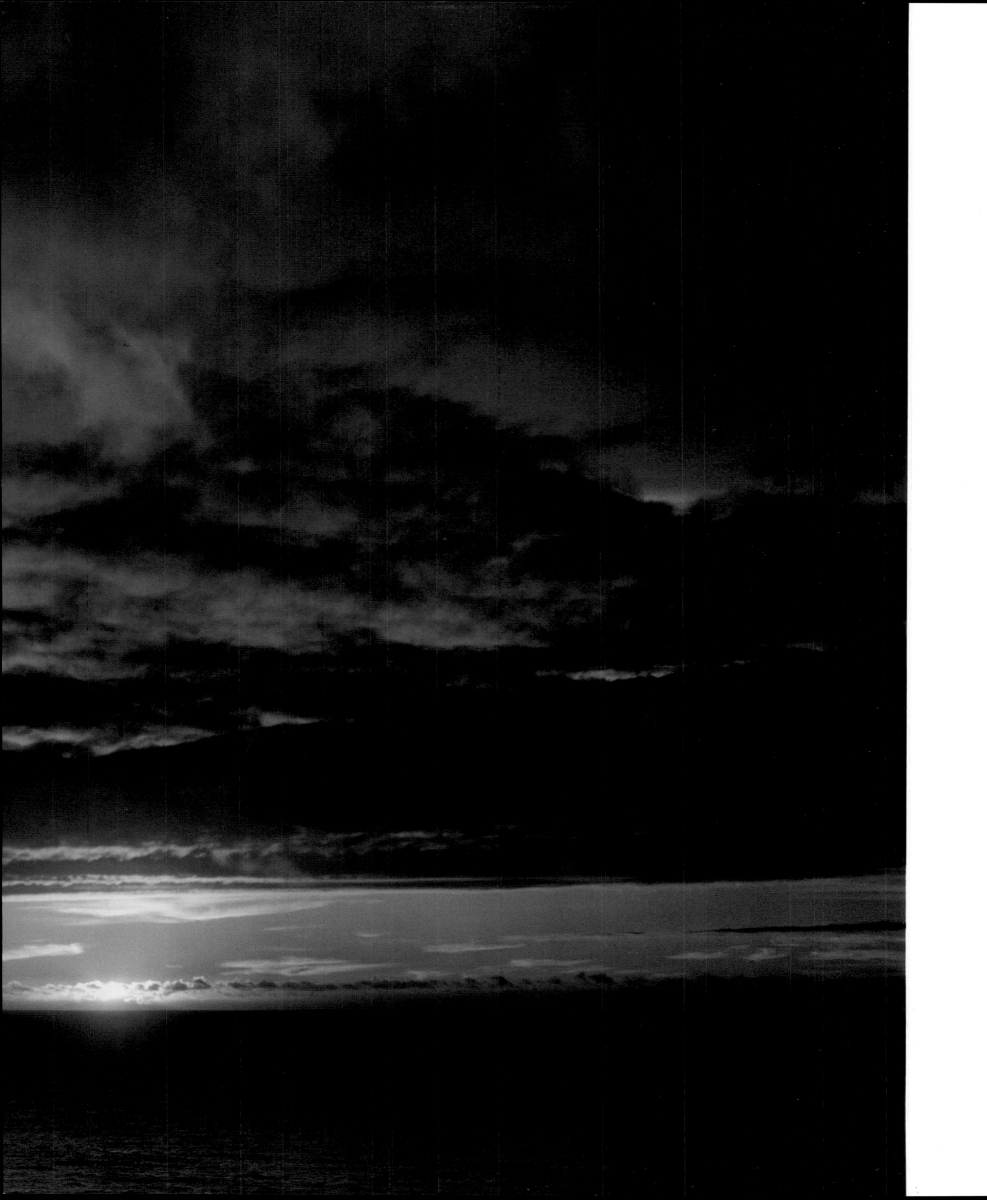

Chronology

January 30, 1919: Born, youngest son of Edward Weston and Flora Chandler.

1927: Makes his first image, a black-and-white photograph of the Mt. Wilson observatories.

1929: The Weston family moves to Carmel.

1937: Becomes the first Weston son to graduate from high school.

1937–1940: Attends the Cornish School of Drama.

1940–1942: Works as a metalsmithing foreman at Lockheed, building Lockheed bombers and P-38s.

1942–1945: Posted as a landlocked sailor and public relations photographer at a naval base in Norman, Oklahoma.

1946: After his father's diagnosis with Parkinson's disease, moves to Carmel to assist him in studio. Sets up a portrait studio.

1947: Begins to work with color film.
Moves with his family to Garrapata and starts a trout farm.

1948: Runs for Congress on Henry Wallace's Independent Progressive party ticket.

1958: Following Edward Weston's death, begins thirty years of printing his father's work.

1970: Leaves his job as Carmel's first Cultural Department Manager to spend seven months sailing to Bermuda with his family.

1971: Has his first solo exhibition.

1973: Spends eight months sailing to Tahiti, the Galápagos Islands, and the South Seas with two of his sons.

1988: Stops printing his father's work, devotes his life to his own photography.

Solo Exhibitions

1971: Focus Gallery, California

1975: Afterimage Photograph Gallery, Texas

1976: Witkin Gallery, New York
Susan Spiritus Gallery, California

1977: Columbia Gallery of Photography, Missouri

1979: Marshall-Myers Gallery, California

1980: Photography Southwest Gallery, Arizona

1981: Halsted Gallery, Michigan

1982: Photography International, Japan

1983: Weston Gallery, California

1984: Yellowstone Arts Gallery, Montana
Catskill Center for Photography, New York

1985: Images Gallery, Ohio

1988: A Gallery for Fine Photography, Los Angeles

1990: Laguna Beach Gallery of Photography, California

1991: Monterey Peninsula Museum of Art, California

More than twenty three-generation shows featuring the photographs of Edward Weston, Cole Weston, and Kim Weston, have toured to France, Germany, Holland, Switzerland, and the United States.

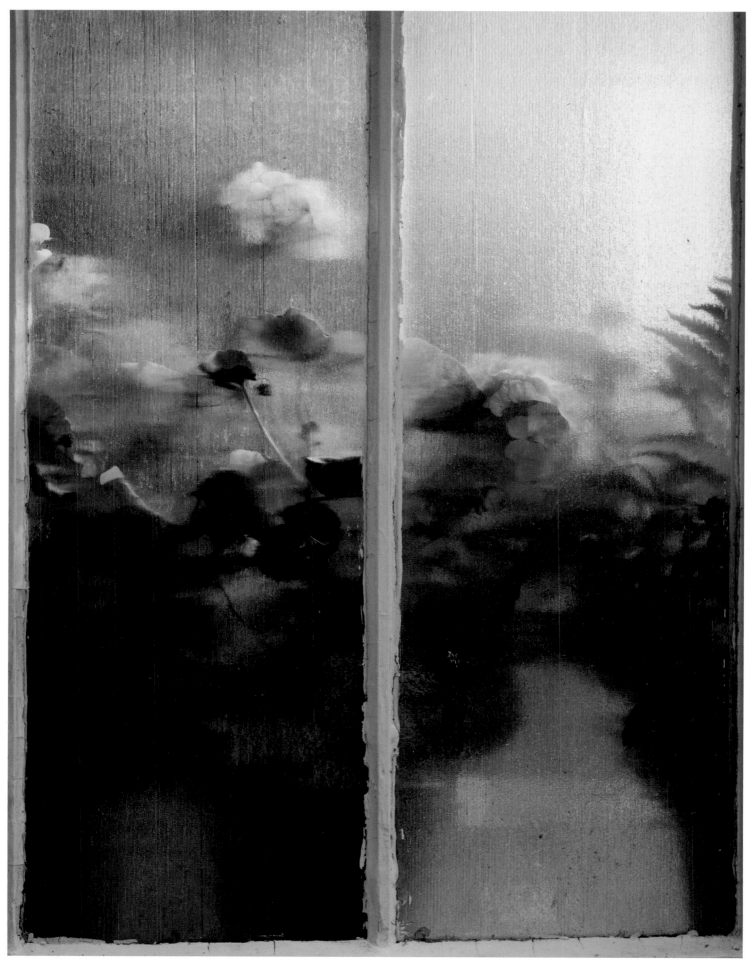

GREENHOUSE, BRADBOURNE, ENGLAND, 1994

Cole Weston and the staff at Aperture wish to express our appreciation to Mack Ray III for his support in helping to ensure that this publication could be accomplished at the highest standard of quality.

Library of Congress Catalog Card Number: 98-84501
Hardcover ISBN: 0-89381-777-5

Design by Wendy Byrne
Printed and bound by L.E.G.O., Vicenza, Italy
Separations by Sfera srl, Milan, Italy

The Staff at Aperture for *Cole Weston: At Home and Abroad* is:
Michael E. Hoffman, *Executive Director*
Vincent O'Brien, *General Manager*
Stevan A. Baron, *Production Director*
Phyllis Thompson Reid, *Editor*
Lesley A. Martin, *Assistant Editor*
Helen Marra, *Production Manager*
Steven Garrelts, *Production Assistant*
Nell Elizabeth Farrell, Cara Ann Maniaci, *Editorial Assistants*

Aperture Foundation publishes a periodical, books, and portfolios of fine photography to communicate with serious photographers and creative people everywhere. A complete catalog is available upon request. Address: 20 East 23rd Street, New York, NY 10010. Telephone: (212) 598-4205. Fax: (212) 598-4015. Toll-free: (800) 929-2323.

Aperture Foundation books are distributed internationally through:

CANADA: General Publishing, 30 Lesmill Road, Don Mills, Ontario, M3B 2T6. Fax: (416) 445-5991.

UNITED KINGDOM, SCANDANAVIA AND CONTINENTAL EUROPE: Robert Hale, Ltd., Clerkenwell House, 45-47 Clerkenwell Green, London EC1R OHT, United Kingdom. Fax: 171-490-4958.

NETHERLANDS: Nilsson & Lamm, BV, Pampuslaan 212-214, P.O. Box 195, 1382 JS Weesp. Fax: 31-294-415054.

For international magazine subscription orders for the periodical *Aperture*, contact Aperture International Subscription Service, P.O. Box 14, Harold Hill, Romford, RM3 8EQ, England. One year: $50.00. Price subject to change.

To subscribe to the periodical *Aperture* in the U.S.A. write Aperture, P.O. Box 3000, Denville, NJ 07834. Telephone: 1-800-783-4903. One year: $40.00. Two years: $66.00

First edition
10 9 8 7 6 5 4 3 2 1

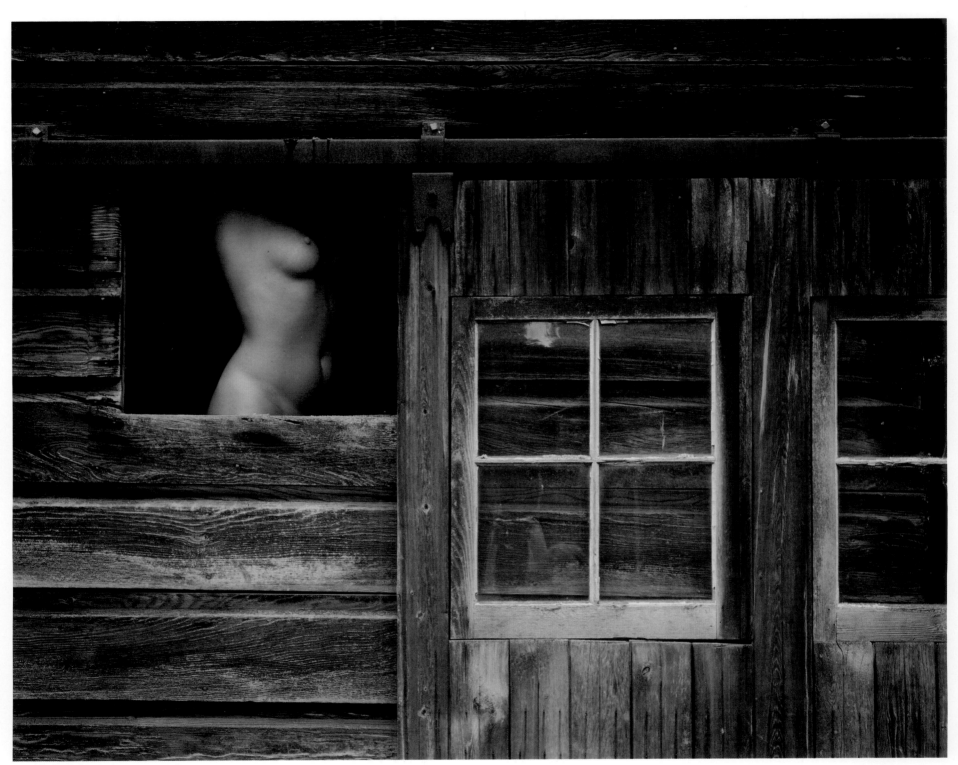

NUDE, CALIFORNIA, 1987

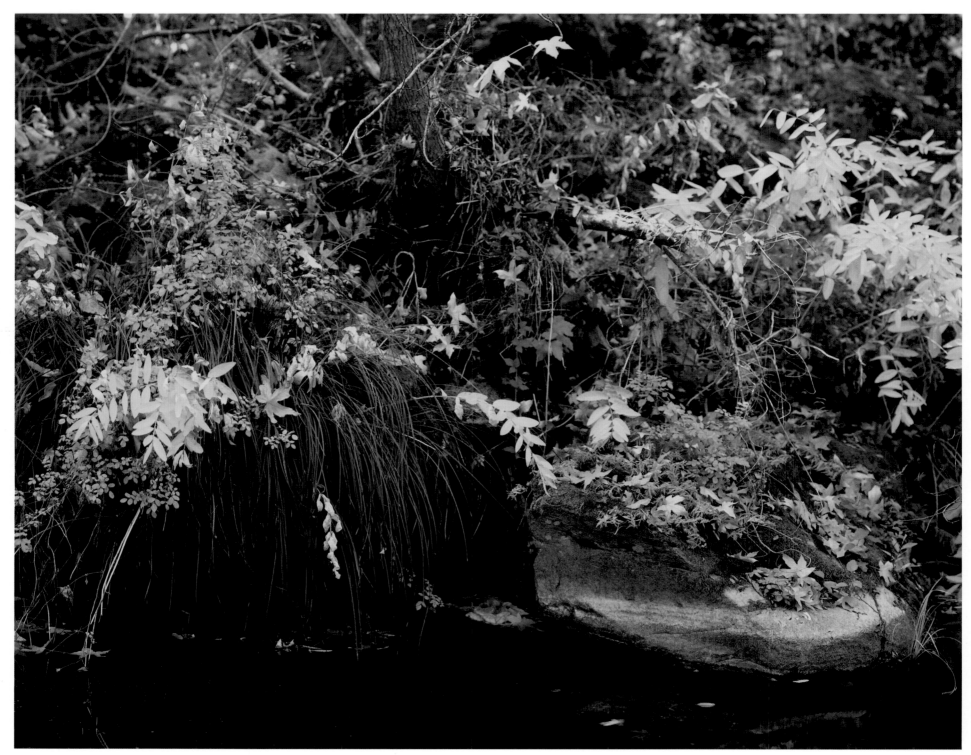

NACIMIENTO RIVER, CALIFORNIA, 1986

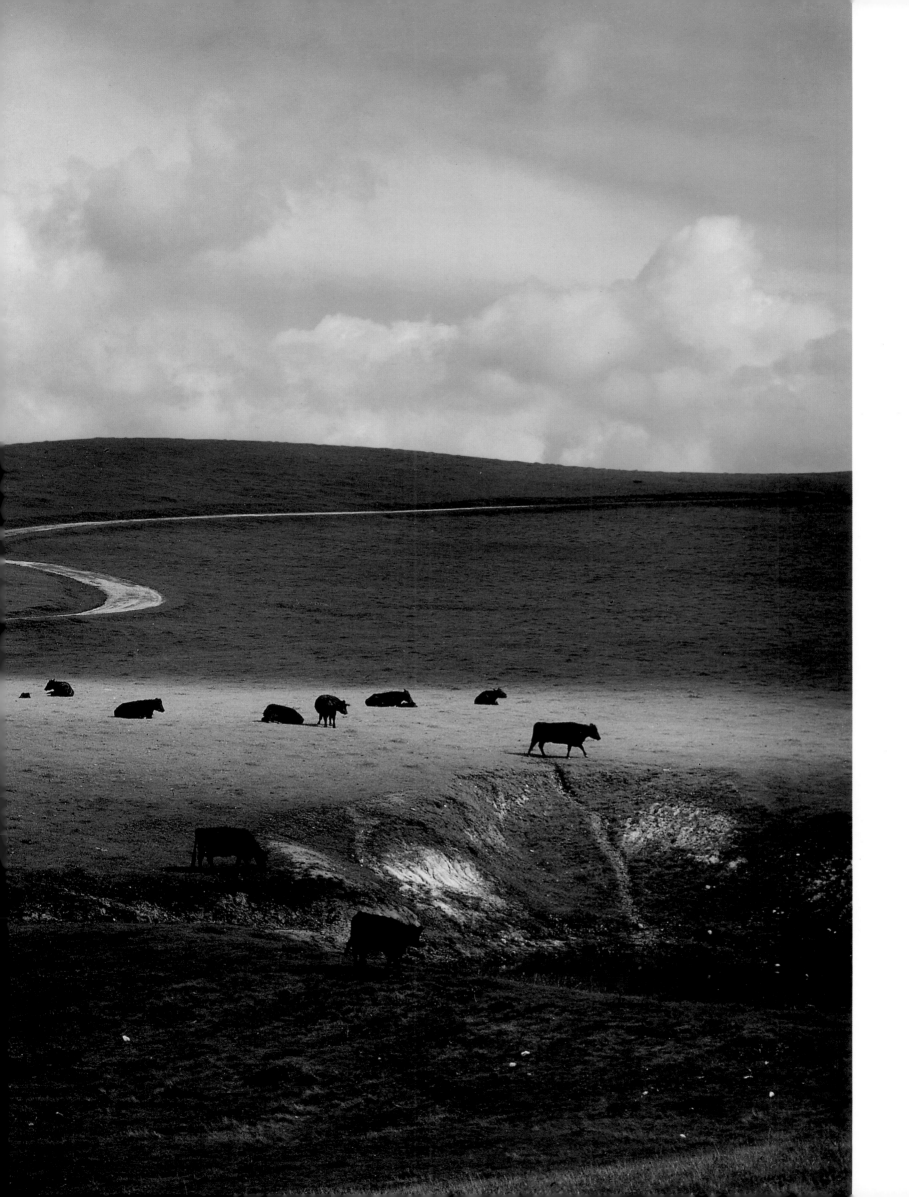

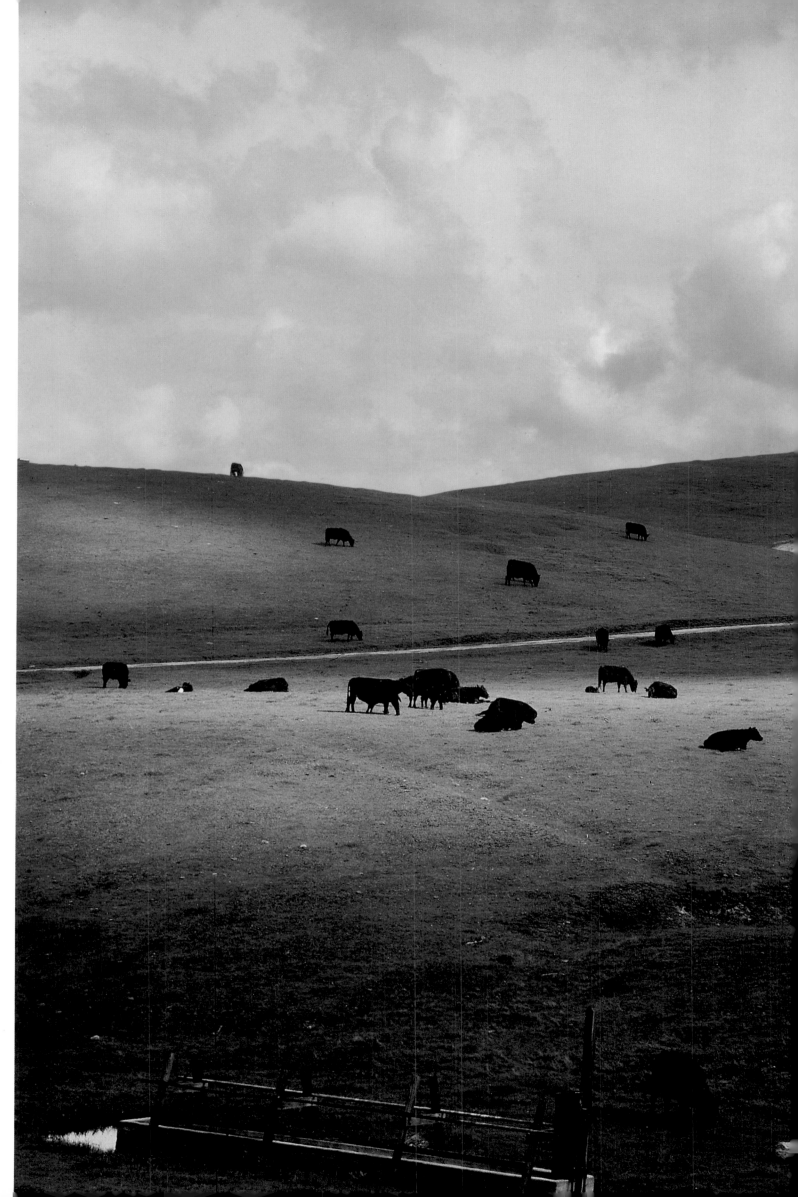

PALO CORONA RANCH,
CALIFORNIA, 1962

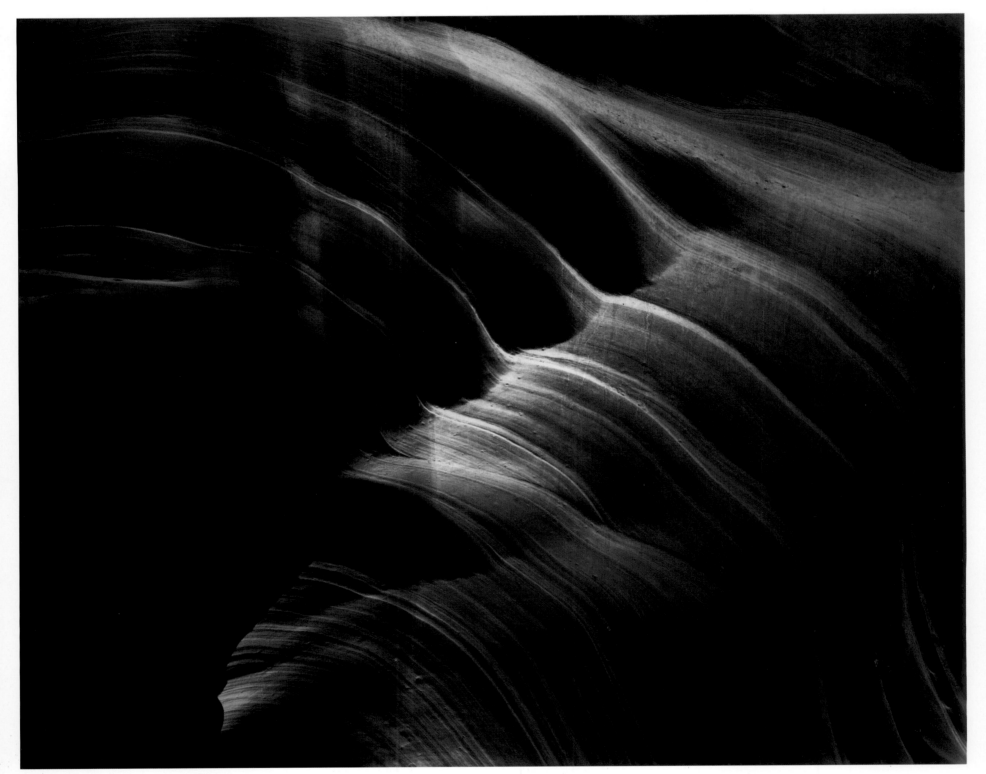

ANTELOPE CANYON, ARIZONA, 1993

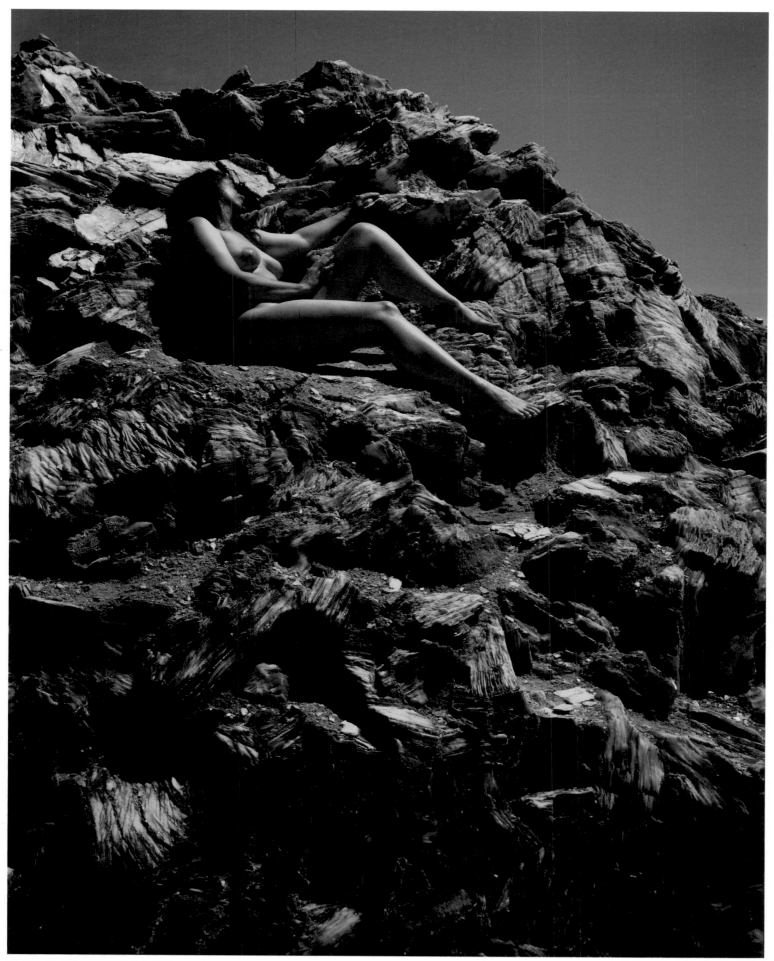

NUDE, GLASS MOUNTAIN, UTAH, 1993

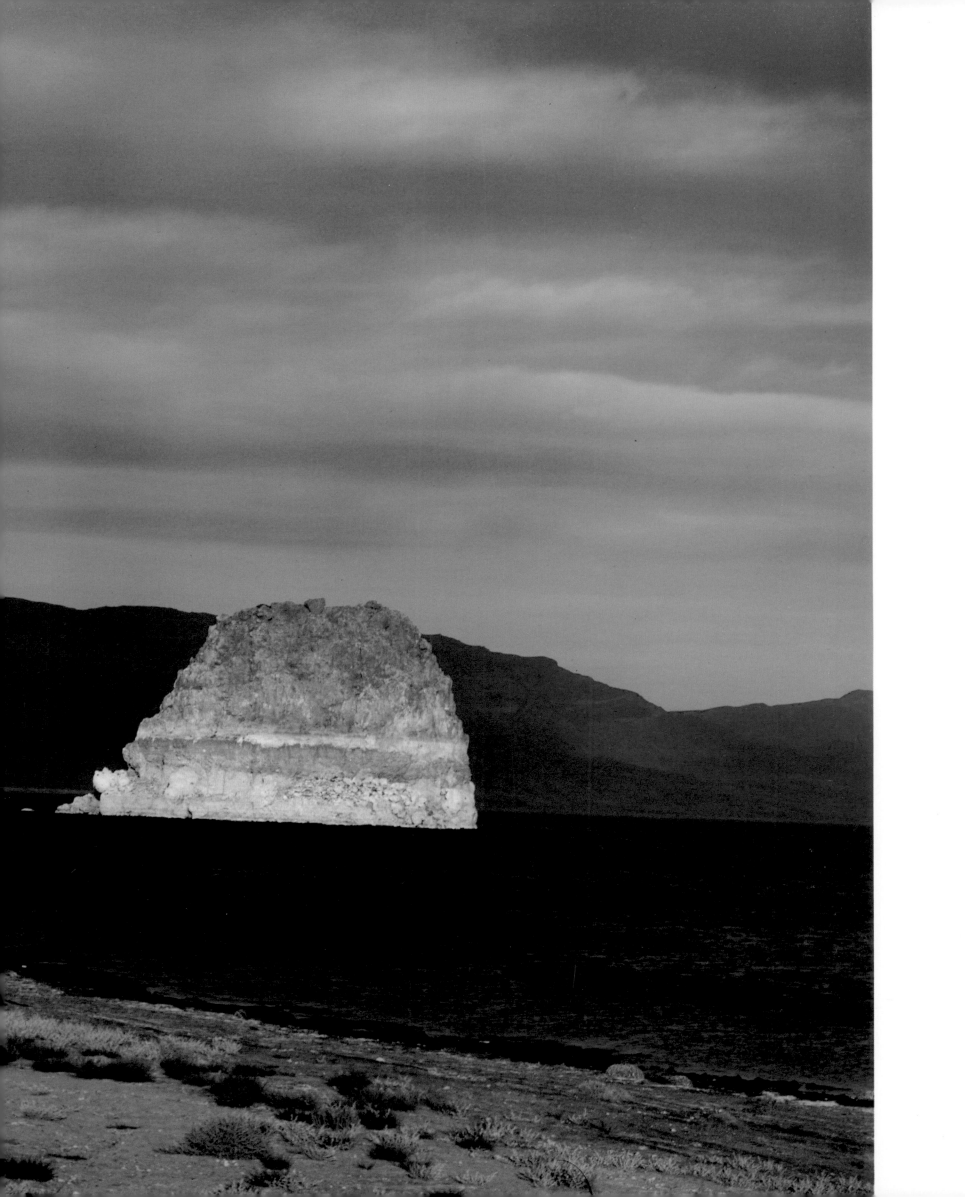

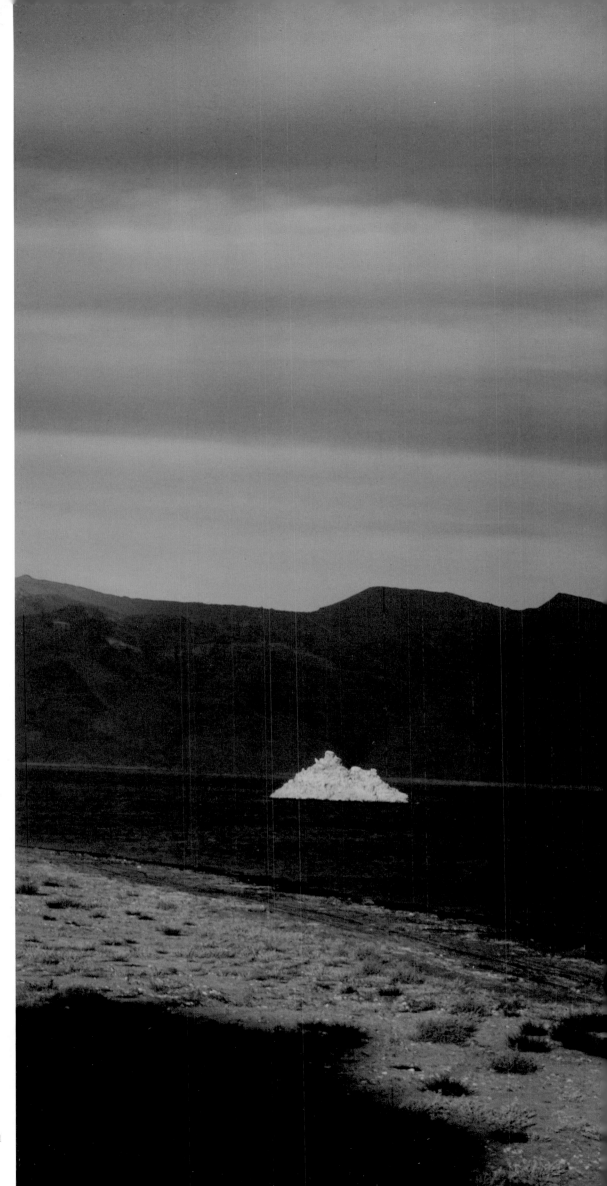

56 PYRAMID LAKE, NEVADA, 1991

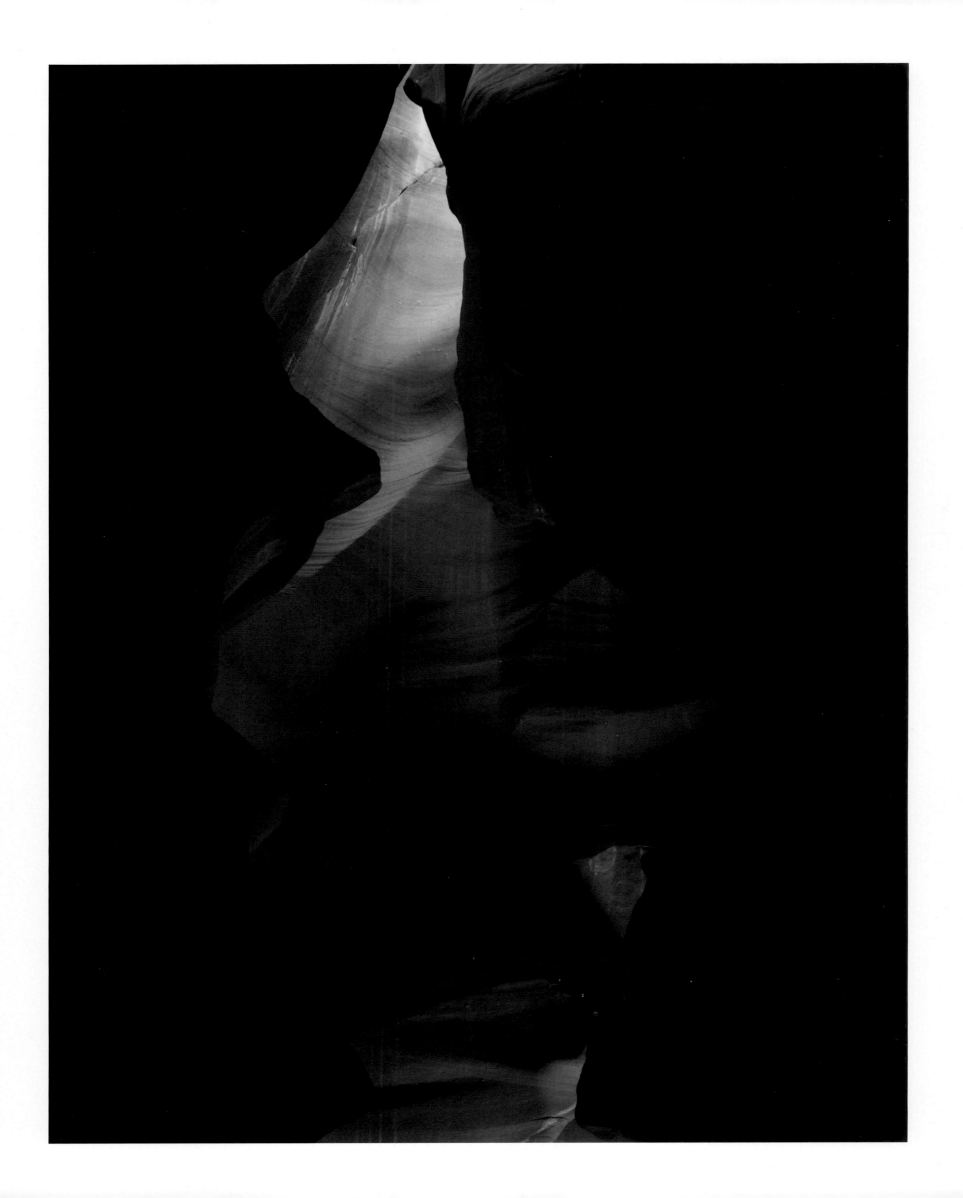

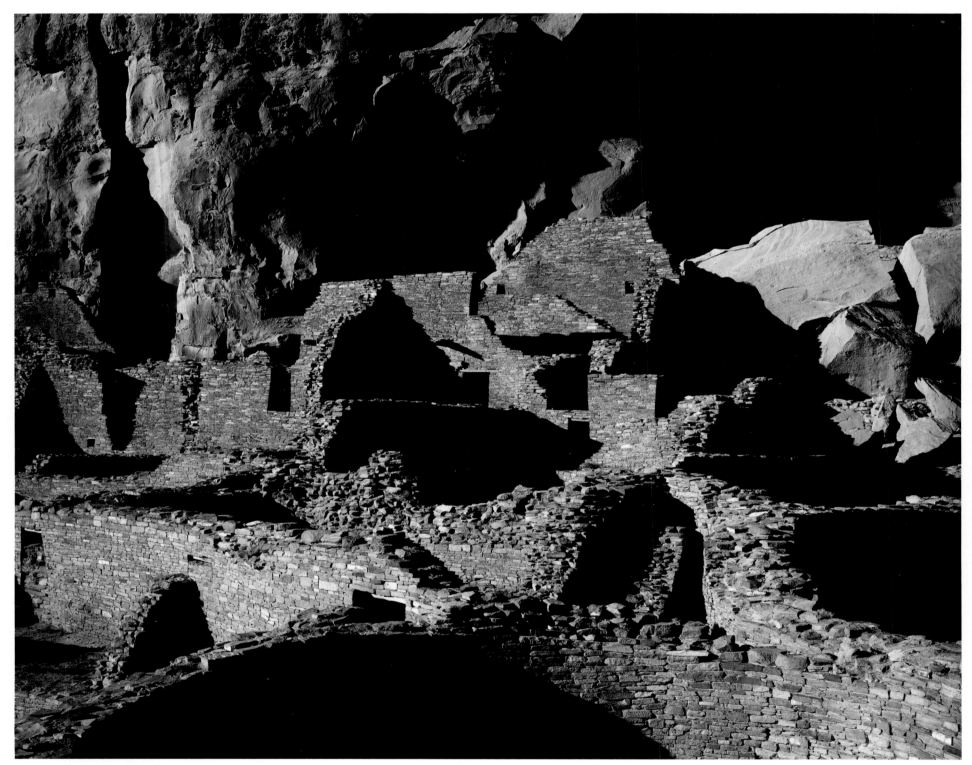

PUEBLO, CHACO CANYON, NEW MEXICO, 1989

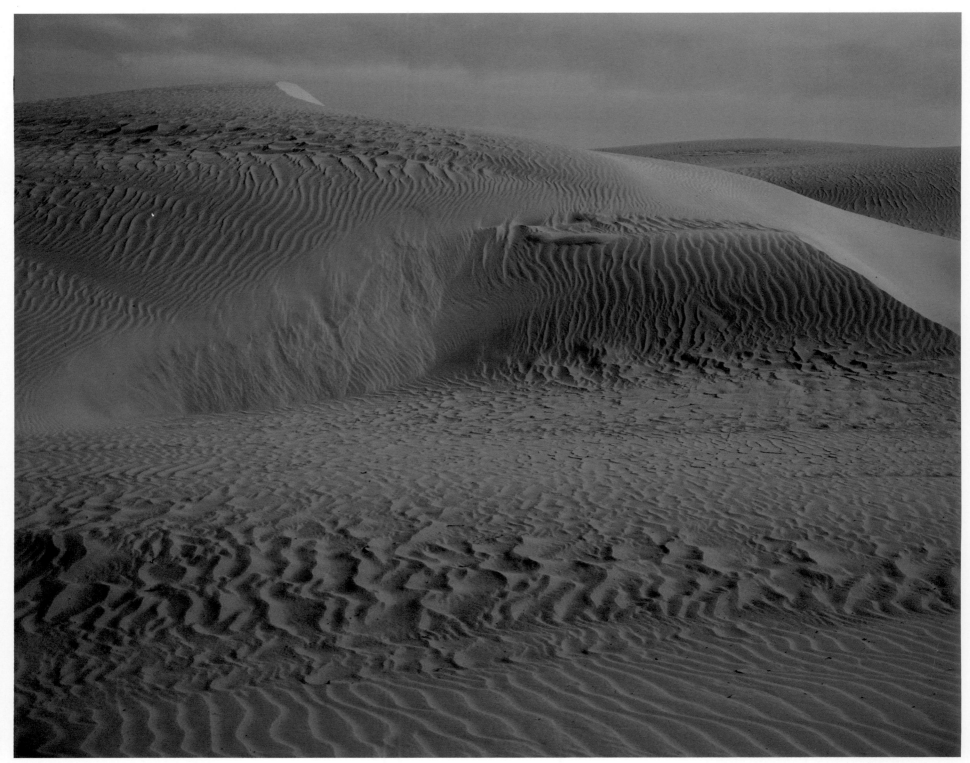

SAND RHYTHMS, CALIFORNIA, 1992

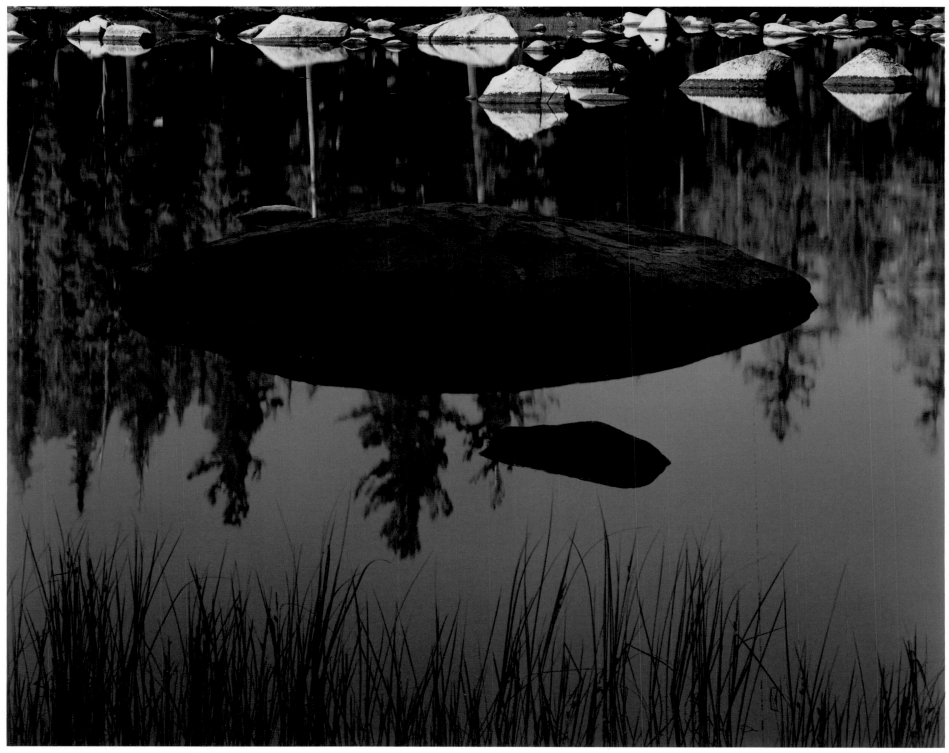

FLOATING ROCK, HIGH SIERRA, NEVADA, 1977

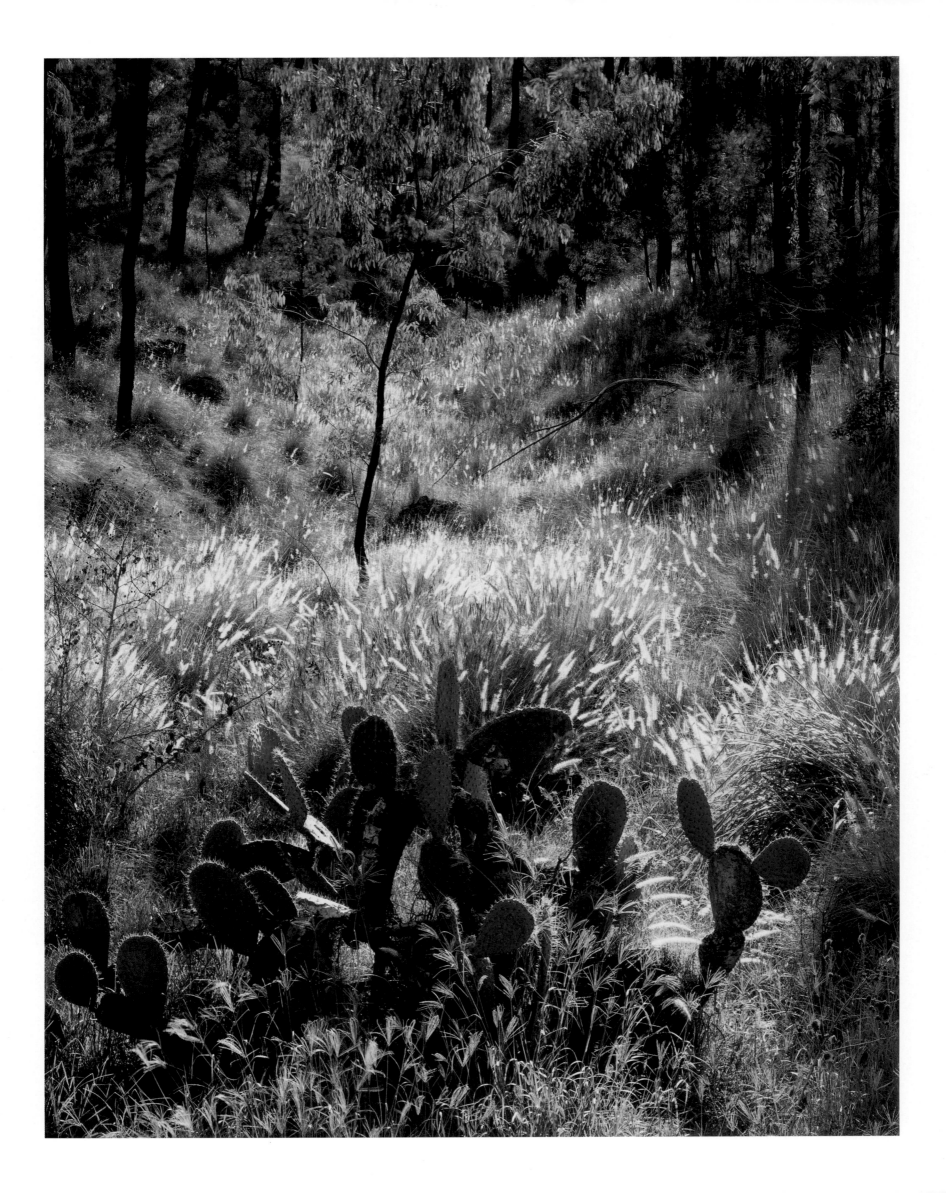

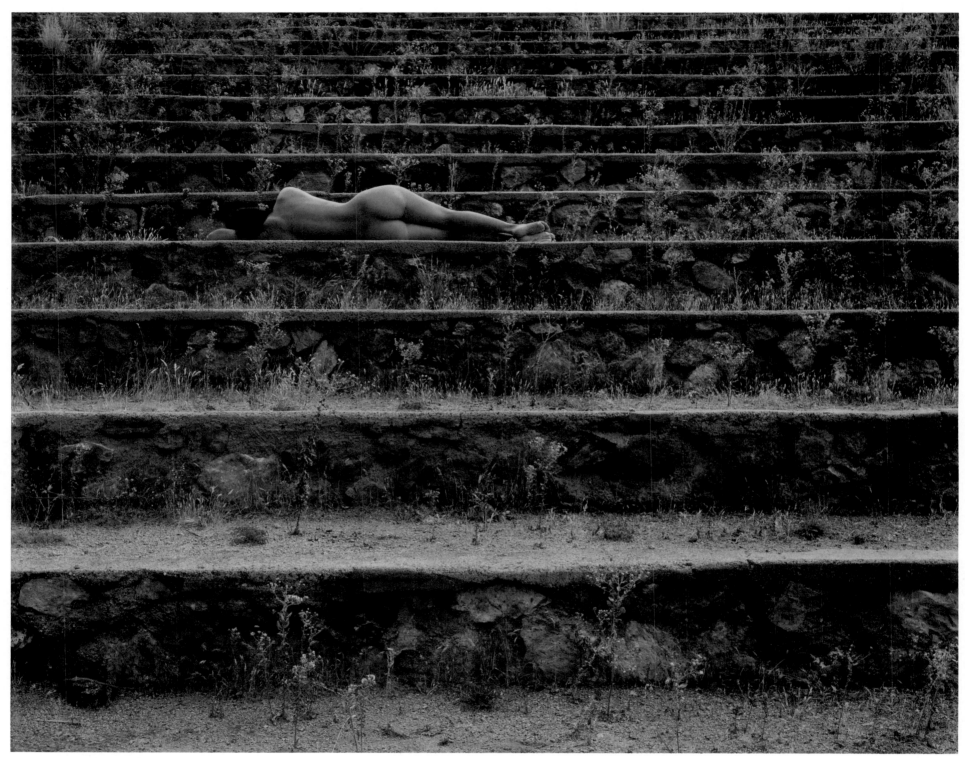

NUDE, ARIZONA, 1979

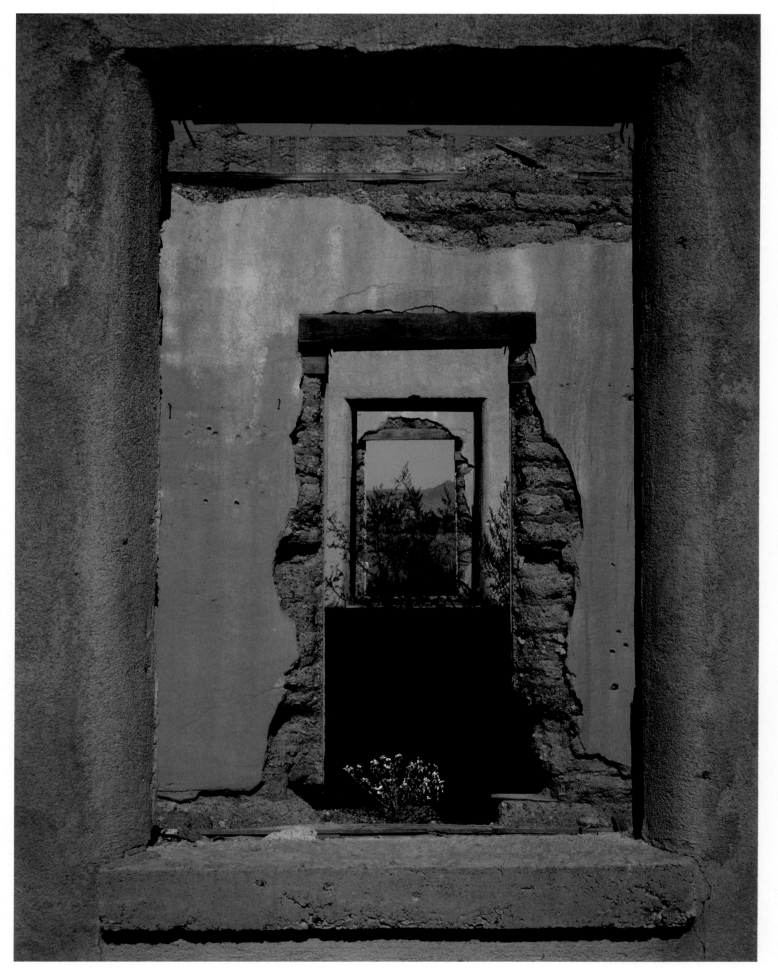

SWANSEA, A GHOST TOWN, CALIFORNIA, 1993

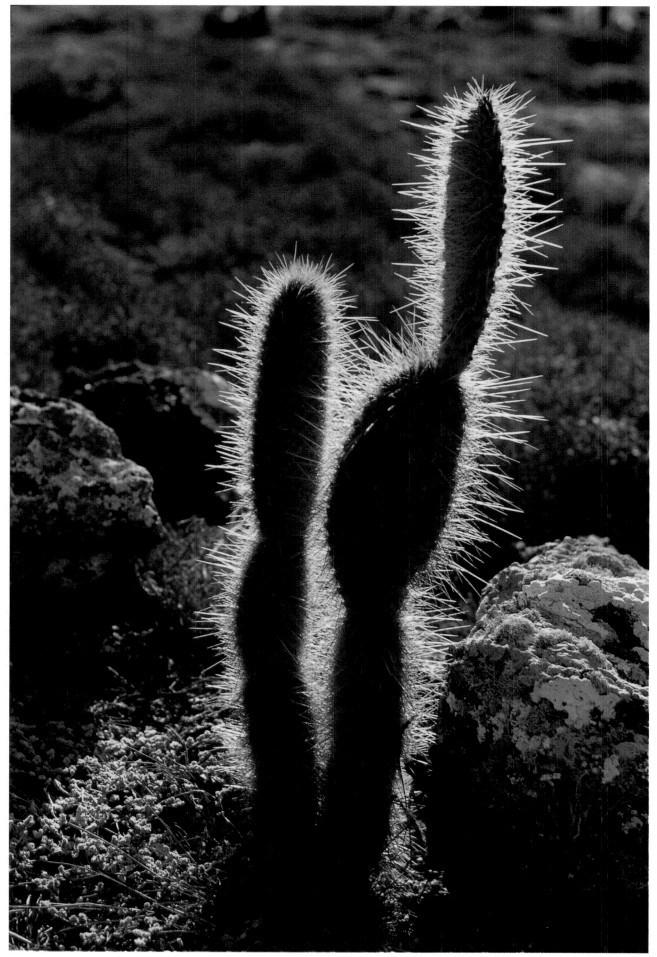

PLAZA ISLAND, GALÁPAGOS ISLANDS,
ECUADOR, 1973

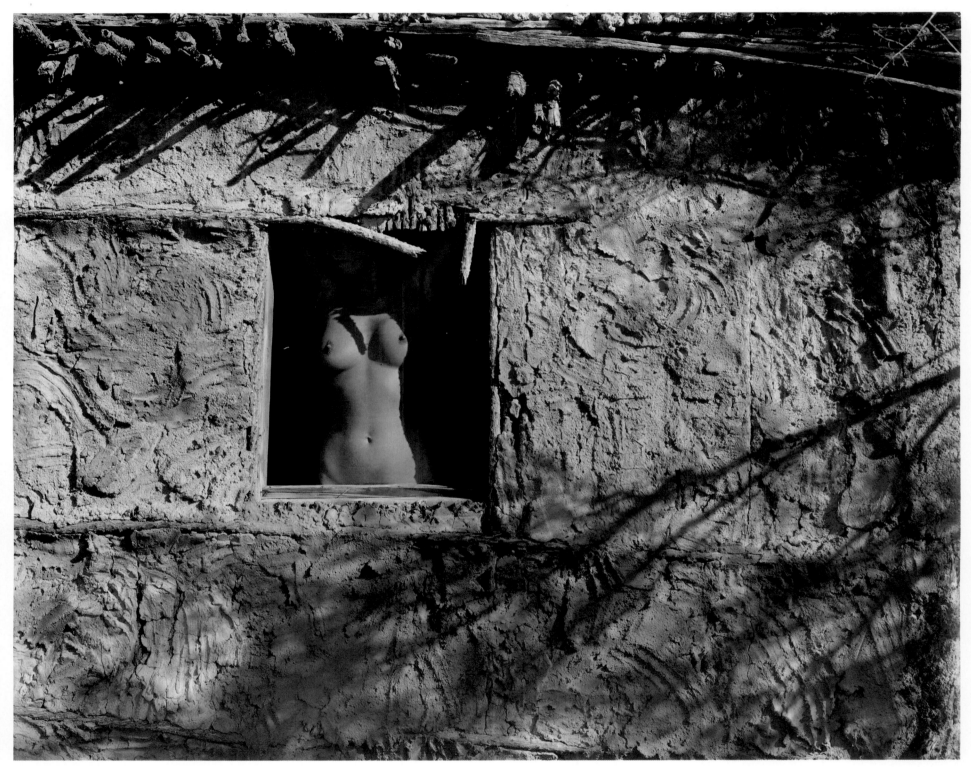

NUDE, ARIZONA, 1979

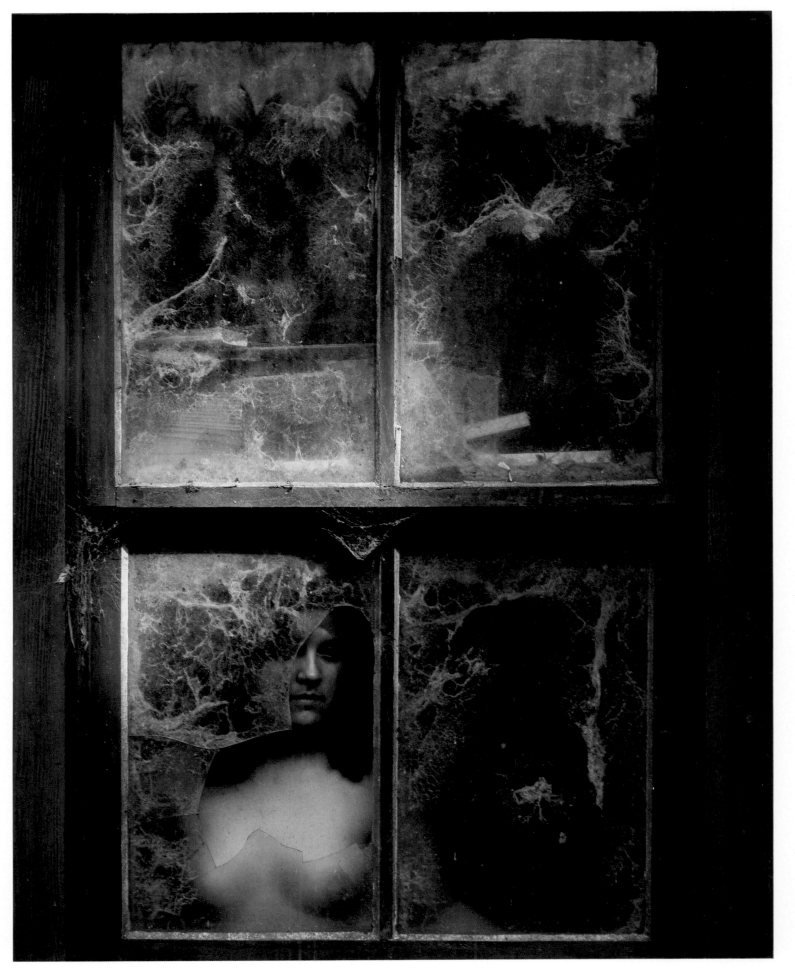

NUDE, FLORIDA, 1983

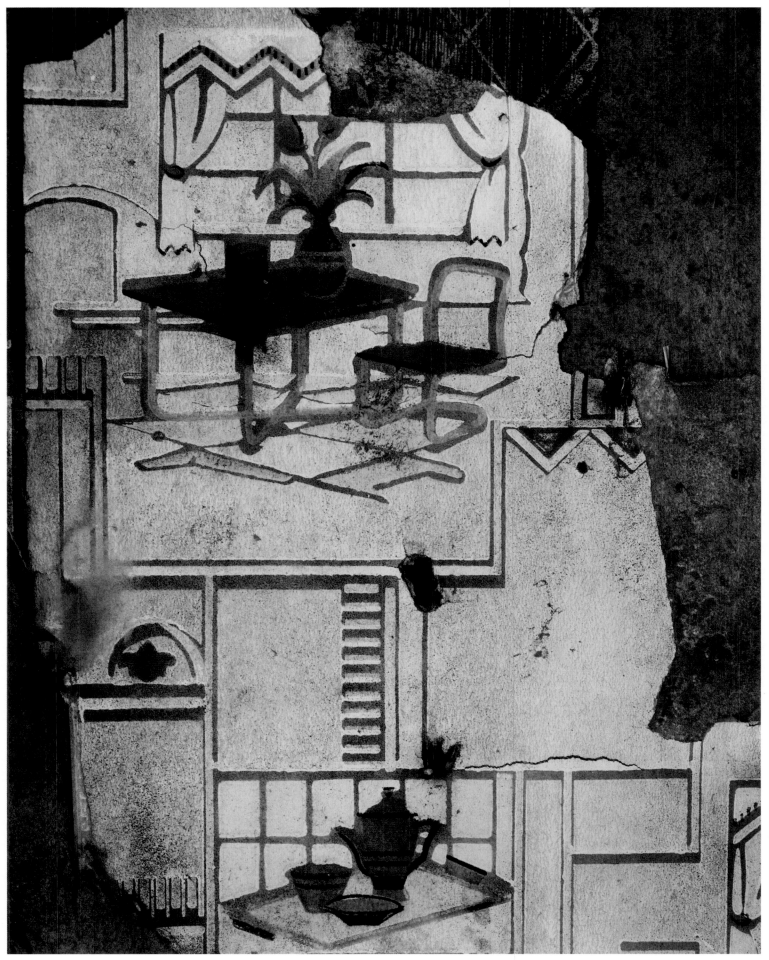

WALLPAPER, OKLAHOMA, 1991

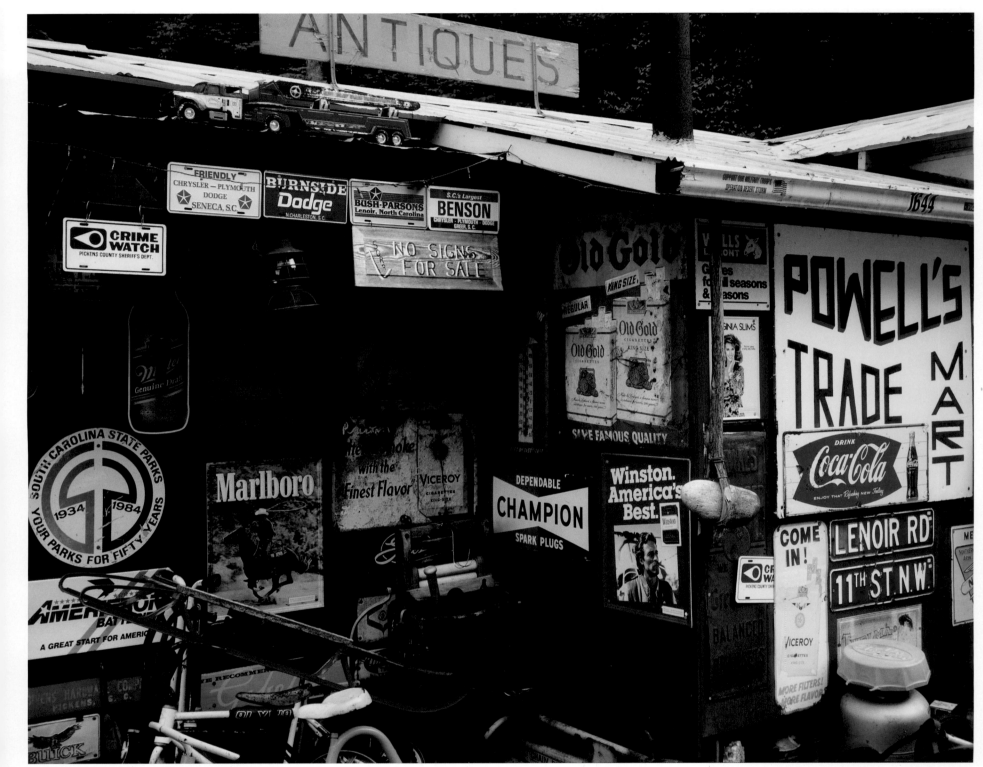

ANTIQUES, TABLE ROCK, SOUTH CAROLINA, 1993

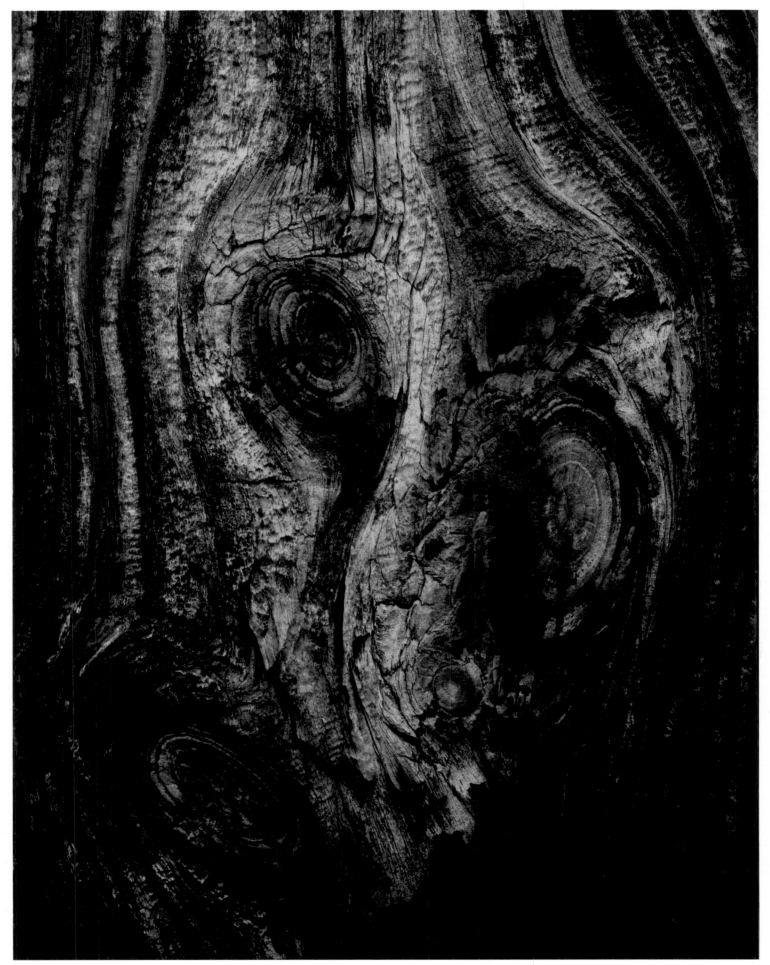

KNOT, ALABAMA, 1991

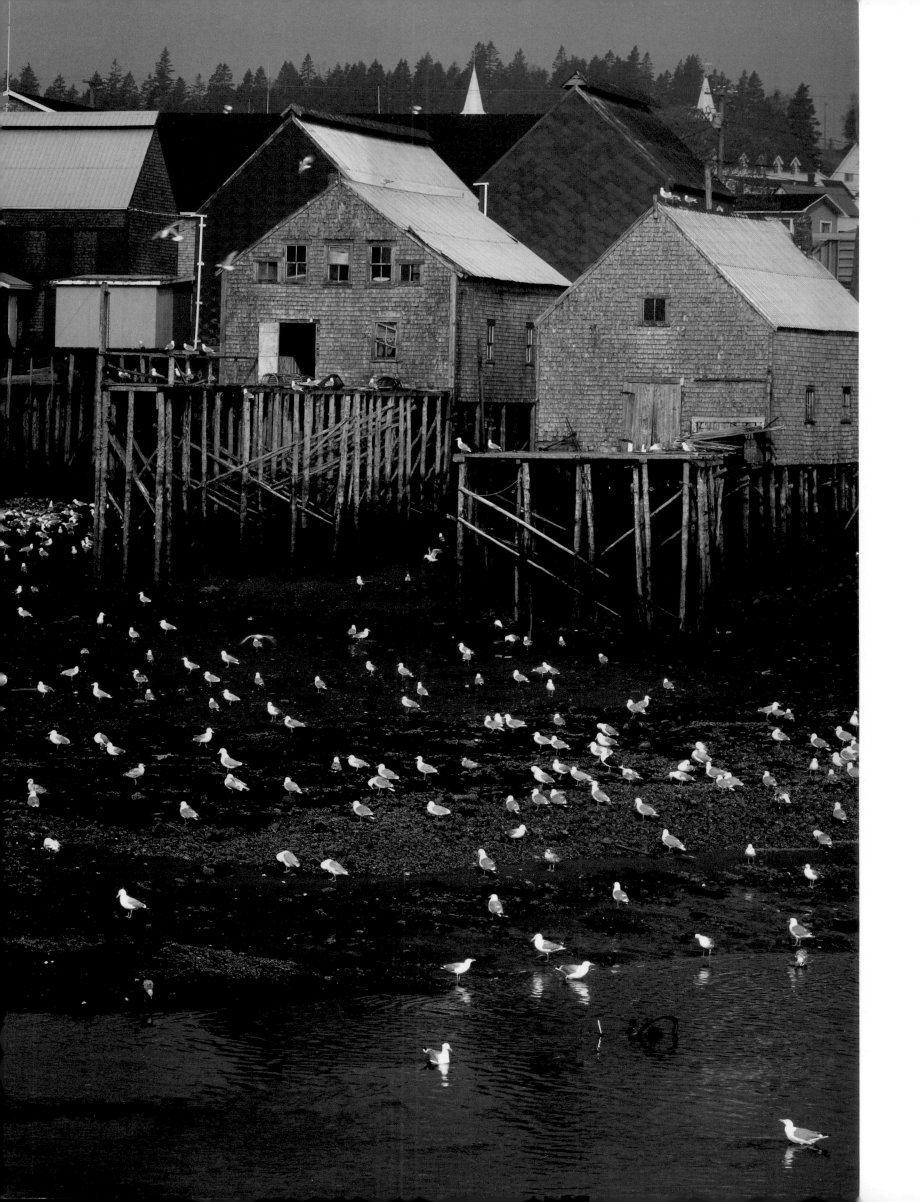